TRUTHS & FICTIONS

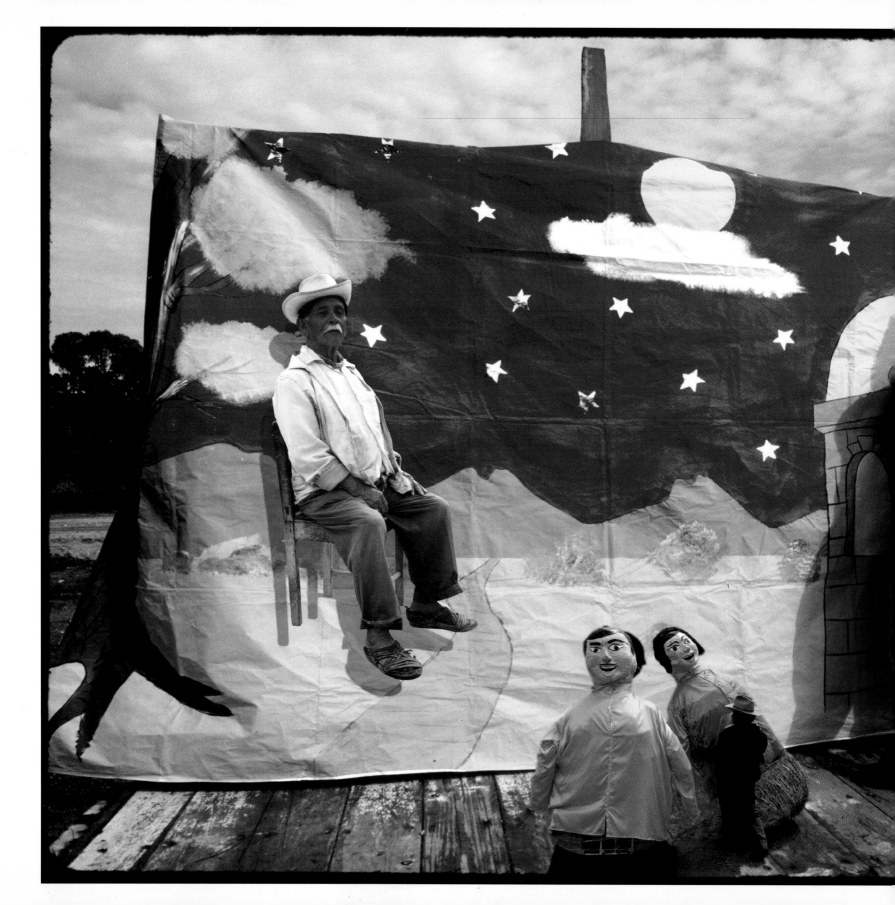

TRUTHS & FICTIONS

A Journey from Documentary
to Digital Photography

PEDRO MEYER

INTRODUCTION BY

JOAN FONTCUBERTA

APERTURE

To you, my son Julito, who during the making of this book
were but a pulsating promise of life in your mother's belly;
to Trisha, who nourished both our souls so well; and to my
granddaughters Michelle and Nicole.

Aperture gratefully acknowledges the generous support of the
John Simon Guggenheim Memorial Foundation

TABLE OF CONTENTS

page 2-3
THE STORYTELLER,
MAGDALENA JALTEPEC,
OAXACA, 1991/92

NOTE: Digitally altered photographs are captioned with two dates: the first indicates the year an
original photograph was taken, the second the year it was altered. Unaltered photographs carry a single date.

PEDRO MEYER: TRUTHS, FICTIONS, AND REASONABLE DOUBTS

■

Joan Fontcuberta

Art is a lie that permits us to state the truth.

PABLO PICASSO

THE PHANTOM OF TRUTH

On April 26, 1937, the Nazi air force levels the small city of Guernica, located in the north of Spain. This military action lacks minimum strategic value; it is a pure demonstration of destructive force launched against a defenseless population.

A few months later, on July 18, the first anniversary of the coup d'état that signified the beginning of the Spanish Civil War, General Franco grants an interview to Seville's ABC newspaper. At the end of the interview, the general tells the journalist: "I'm going to show you some photographs of Guernica." The journalist describes the images as "magnificent prints on glossy paper that reproduce the ruins of a city totally destroyed by shrapnel and dynamite: sunken homes, entire streets destroyed, shapeless piles of steel, rocks and wood." "It's horrible, General," exclaims the journalist. "Yes, horrible," responds Franco. "Sometimes the necessities of war or repression can lead to such horrors. This is one reason I've been moved not to use these photos that were sent to me a few days ago. Because, if you look closely: they are not of Guernica" Second act: Franco shows him the authentic captions of the photographs he has on hand. Indeed, they are not of Guernica, but rather of another city, thousands of miles from Spain. Franco says nothing further. The demonstration has ended and the journalist winds up the interview by venturing, "What good those marvelous pictures would do, for example, on the front page of the *Daily Express*."[1]

It is easy to imagine the perplexed expression of the journalist and the cynical smile of the general. Having accommodated the myth of objectivity, photography has not only permitted deceit but facilitated it. Franco didn't pretend to confront the barbarism of "the others" to justify his own. His strategy didn't consist in showing (with photographs) that all sides commit atrocities, and that his own actions could thus be justified. Instead, it consisted in negating the stability of the photograph-as-document. This allowed him to make the case that everything is propaganda, a view of photographic imagery that has served many political interests throughout history. Photographs aren't in charge of corroborating our truth or establishing our power of reasoning, but of exclusively questioning the hypotheses on which others can base their truth. Those magnificent glossy photographs, so praised by the journalist, told us little of the original situation to which they alluded; since the information they presented was anchored in nothing more solid than what they themselves could offer, the images betrayed the promiscuity of their multiple meanings. Photography seems limited to describing surfaces, and for that reason its commitment is form. It seduces us by its proximity to the real and gives us the sensation of putting truth at our fingertips . . . and then it throws a jug of cold water in our face.

The Spanish Civil War caught Picasso flirting with Surrealism. During this phase, his work frequently contained symbolic content derived from Mediterranean mythology, making it look like a battle between dreams and reality. But the tragedy of Guernica shocked him profoundly, and became the moral

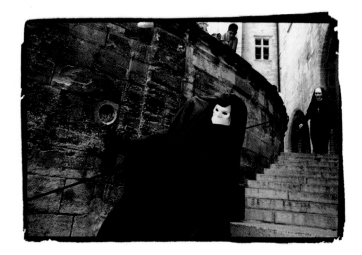

New questions about the ontology of the document are precisely what give rise to the work Pedro Meyer presents here. *Truths & Fictions* certainly stimulates a debate about the contrast between two cultures, their contradictions, and the unresolvable conflict between North and South. On one side, the United States appears as a paradigm of the illusion of abundance and material well-being; on the other, the Mixtec Indian people of Oaxaca, Mexico, appear deprived, but make up for it with their colorful spirituality and exuberant ancestry. It's an argument that is not foreign to us, and Meyer knows how to irritate and move us; he knows how to provoke the smile that precedes uneasiness; through irony, he knows how to filter the crudeness of desperate situations. In other words, he knows how to win us over to his cause.

Though this is an impressive message, even more important here is the emergence of a new documentary consciousness. This is a consciousness that cries out its documentary nature, and is nevertheless capable of freeing itself from the modus operandi that has come to define successive documentary models. The use of digital technology, with which the majority of these images were made (modifying color, accenting the contrast or texture, integrating fragments of different ori-

detonator that would provide the theme for a work of art that many critics consider the most important painting of our century: *Guernica*, the mural for the pavilion of the Spanish Republic, in the International Exposition in Paris of 1937. On May 1, a few days after the bombing, Picasso began to trace the first sketches. The expressiveness and emotion would eventually make this image a symbol of the fratricidal struggle of a people, and would universalize the suffering of the small martyr population.

Nevertheless, Picasso was not an eyewitness to the bombing. Did he find out about it via the press? Did his friends tell him about it? Did he receive accurate and impartial information? Today, perhaps these questions are trivial. Hasn't Picasso's painting done more for revealing and setting in history the holocaust of Guernica than all photographs, both authentic and false? What matters in a document—the intention that originated it or the effect it elicits? What is important—its aesthetic status as evidence or the social function that is assigned to it? *Guernica*, a monument erected against oblivion, resists being just a painting. History, as Michel Foucault pointed out, transformed the monument into document[2]; but today it isn't always true: often monument and document are situated on the same two-way street.

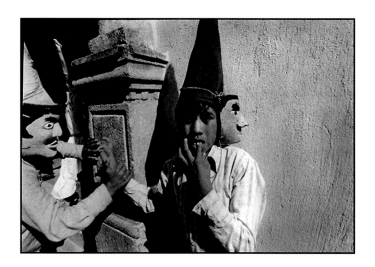

top
THE DEMIURGE, 1994/94
left
THE DOUBLE MASK OF
OCUMICHU, 1980

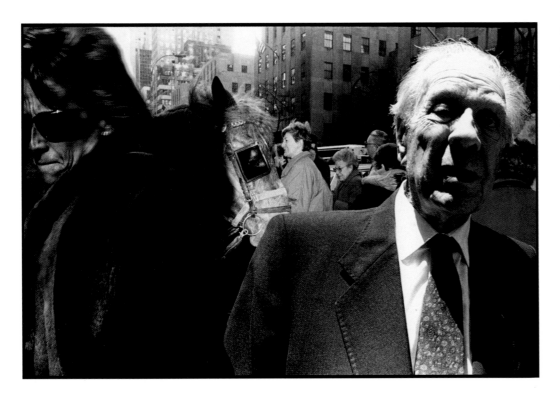

ory—to create modern-day masterworks like Picasso's. In the end, computers, like cameras, have been revealed as technological mechanisms that make sense of the events that shape our time.

What's more, the computer has become a sophisticated technological prosthesis we cannot do without. It affects all spheres of our daily life. It is not strange, then, that today so many artists are stimulated by the creative possibilities of digital media. Among those who use the photographic medium, Jeff Wall, Thomas Ruff, and Yasumasa Morimura provide three examples from diverse geographic origins. In their work, and in that of many others, the collaboration of the computer, even though obvious, is obscured within the "naturalness" of the process. For them, it is a resource that facilitates the solution to a certain problem—it is another accessory, like a telephoto lens or a filter (which also intervene in the vision of the camera, distancing it from the normal vision of the naked eye). By contrast, Meyer's key conceptual proposition is the camera's symbiotic connection with computers.

BORGES ON 5TH AVENUE, NY, 1985/94

gins), will scandalize the fundamentalists of traditional documentation. The spontaneous question in the minds of critics: why has an author, who for more than twenty years belonged to the cult of straight photography, suddenly converted to an opposite religion? Meyer's response is always the same: he sees himself as a documentary photographer, in the sense that the interpretation of reality remains his main priority.

Put simply, the tools have evolved, consequently making the creative repertoire richer. But, Meyer insists, the expressive aim is identical and consistent with his previous work; only the strategy may have changed. Perhaps, deep down, Meyer wants to escape the inherent fate of photography that leads—as in the case of the false shots of Guernica—to ambiguity, if not to the most radical distortion. On the other hand, all of today's technological resources could be used to avoid ambiguity and to make an indelible mark on our mem-

FROM THE SILVER TRACE TO THE DIGITAL TRACE

Meyer's approach comes out of a critical reflection about the nature of the photographic medium and the mutation from its photo-chemical origin to its electronic stage. Traditionally, photography is understood as a result of a train of thought that assumes direct observation of nature and the rigor and precision of science, providing the only access to a confident knowledge of the physical world. In fact, photography was born as the culmination of an "instinct": the instinct of imitation, the obsession with re-presenting nature that has evolved throughout time, from the graffiti found in prehistoric caves to the present-day sophisticated technology. "Realism" can be seen as the ideology of representation, or as a branch of the arts or humanities. But from the sociological and anthropological perspective, the realist vocation obeys a sort of reflex mechanism; it is a register printed in the biological memory of humanity. The mimetic act (concerning gestures, sounds,

and images) is one approach to understanding the world. Computers were born at the heart of another rationale, more speculative and nonlinear; they also appeared as the culmination of an instinct: that of information processing—that is, of storing, ordering, and evaluating data in order to generate understanding. Both instincts serve a broad range of needs, from the mystical (religion, art, and so on) to the pragmatic (economics, politics, and business). That cameras process analog information and computers digital information is not as relevant as the fact that together they combine these two aspects of intelligent activity. In *Walking Billboard, New York*, 1987/93 [page 16], Meyer comically illustrates this concept: a character whose head is crowned with a grotesque accessory of a camera and a computer, a clear allusion to the hybridization of the new visual thought.

The introduction of previous technological improvements in photography (electronic automation, magnetic recording devices, teletransmissions, etc.) didn't substantially affect the nature of the medium, nor that of its satellite values. Similarly, the metamorphosis from silver grains to pixels is not in itself that significant; after all, the silver-grain structure of actual photographs has already been replaced in the print media by the photomechanical dot grid of image separations. However, these do not constitute totally synthetic images; rather, they are simply digital records or adaptations of optically generated images. When the camera is the recording device, a high degree of what philosopher Charles Sanders Peirce called "indexicality" is guaranteed: the metallic imprint in the original photograph is transformed into a digital imprint—but an imprint nonetheless. But the true computer-photography fusion gives rise to a powerful electronic laboratory, which introduces factors too decisive for us to sustain our conventional views of image making. The immediate foreseeable effects can be summed up in three paragraphs:

a. *the use of software that replaces airbrush and photomontage.* Its spread and assimilation in the general public and among

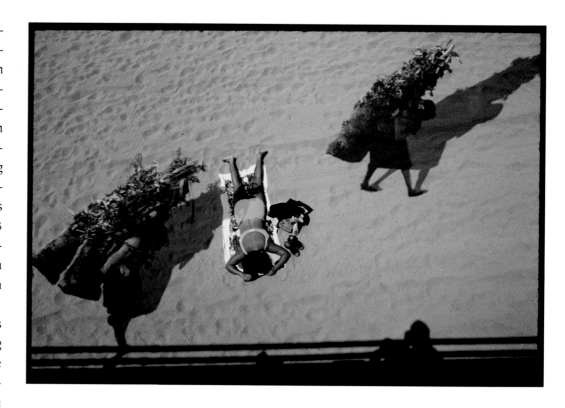

amateurs could end the myth of photographic objectivity (not so much because of the nature of the technical manipulations, but, rather, because the ease of this manipulation will make it the standard). Photography will be discredited as a reliable witness, its credibility no longer among its intrinsic qualities, but within the photographer as author. Having corrupted the photograph's deceptive halo of truthfulness, digital technology will show that photography has been converted into a primitive, degenerate medium.

b. *the creative application of "noise" or "parasites" generated from the interface between the camera (analog) and the computer (digital, synthetic, virtual).* It's what has been called "infographics." That is to say, a vocabulary of graphic, kinetic, and acoustic effects, independent of an external reference to the system, which are true products of digital technology. The precociousness of this technology and the immaturity of its

TRANSPARENT WOMEN,
1986/94

applications lead to many neophytes, as well as artists who are scarcely self-critical, being fascinated by the spectacle of the technology and mere gratuitous effects, which are not yet charged with content.

c. *the fast and easy interaction between artists, works, and the public.* The artist no longer offers a petrified work, a fossil; rather, he or she facilitates an open dialogue with the spectator, who participates and shares in the creative dynamic. All this surpasses an authoritarian and obsolete concept of authorship, democratizing information and the artistic experience, and increasing empathy in the viewer. Meyer's presentation of *I Photograph to Remember* and *Truths & Fictions* on CD-ROM lead in this direction, as they join diverse media of expression on a single, multifaceted platform.

FROM THE FORM OF EVIDENCE TO THE FORMING OF OPINION

Will these effects denaturalize the documentary essence of Meyer's work? Only a myopic conception of the document will lead to an affirmative answer. In any case, the concept is worth investigating in more detail. An encyclopedia of photography, immediately after conceding that any photograph, "even fictional or manipulated," contains documentary values, offers us this gem: "Documentary photographs are thought of as those in which the events in front of the lens (or in the print) *have been altered as little as possible from what they would have been, had the photographer not been there.* To this end, successful documentary photographers have developed various approaches and personal styles of behavior while working that permit them to be present on the scene they are photographing while *influencing it minimally*"[3] (my emphasis). Although this definition is more pragmatic than theoretical, it is naive because of its imprecision, yet absolutely explicit in its point that we are not talking about aesthetic or philosophical categories, but, rather, of a credo. The definition suggests a programmatic doctrine that competes with ethical standards, and for that reason morally sanctions those op-

tions that are considered virtuous and designates those that are considered venial or mortal sins.

From this, a subsidiary consequence is derived: an encounter with aesthetics that reinforces, or at least doesn't interfere with, the appearance of authenticity in the content of a photograph. Some of the prophets of this doctrine will endorse the straightforward nature of the camera with regard to the subject, in order to purge their souls of any subjective fickleness. Others will impose the penitential strict use of diffused lights to avoid atmospheric shadows, and will limit the tonality to an ascetic black and white, or the vision to a single lens, closest to ordinary ocular perspective. Avoiding temptation will require an enormous respect for the original focus and size of the negative. Finally, the use of borders on the print will be the ultimate profession of faith.

Near-religious fervor notwithstanding, this kind of iron discipline becomes a mere exercise in style, an aesthetic workout, a laudable form of craftsmanship—not exempt of a certain exotic interest. However, when formalized as a doctrinal body, this approach ends up restricting freedom of expression, and threatens to reduce the documentary to a notion of style. As Trinh T. Minh-ha has written: "The documentary can easily thus become a 'style' . . . only an element of aesthetics (or anti-aesthetics) which . . . reduces itself to a mere category or a set of persuasive techniques. . . . The result is the advent of a whole aesthetics of objectivity and the development of comprehensive technologies of truth capable of promoting what is right and what is wrong in the world, and by extension, what is 'honest' and what is 'manipulative' in documentary."[4]

HONEST MANIPULATION: TRUTH AND PERSUASION

As a matter of fact, many masters of documentary photography had no difficulty in breaking the rules (in secret, of course) and engaged in "manipulation" in order to be "honest." From the landscapes of the nineteenth century, obtained by superimposing various negatives, to the staged or composed photographs by the grand advocates of social documentary and

humanist photography—such as Robert Doisneau, Eugene Smith, or Sebastião Salgado—some of the most symbolic images of all the ups and downs of the last century and a half were obtained in this manner. And yet nobody reproaches these photographers, for they realized that their mission was not to give form to the truth, but to persuade. Truth is a difficult concept to grasp: verisimilitude is much more tangible.

Of course, verisimilitude is not incompatible with manipulation. We must avoid hypocrisy: "manipulated photography" is a redundant term. All photographs are manipulated. Framing is a manipulation, focusing is a manipulation, choosing the moment to snap the picture is a manipulation. To create is to accept the challenge of penetrating the focal point of this crossroads. No human action exists that does not imply manipulation. Therefore, manipulation is exempt of moral value per se, and the fact that it carries negative connotations is a judgment that should be avoided. What are subject to moral judgment are the criteria or the intentions that are applied to manipulation. And what is subject to critical judgment is its effectiveness.

X-RAY REALISM

The cathartic journey of manipulation of *Truths & Fictions* comes as a result of the voyage on which the photographer embarked from 1987 through 1991 to photograph the United States. Its unavoidable precedent is Robert Frank, whose acidic and dislocated gaze took a long time to be accepted. In another book of Meyer's, the essence of his earlier work, *Espejo de Espinas* (Mirror of thorns, 1986), Carlos Monsiváis ends the introductory essay with words that could apply directly to Frank's images, stating: ". . . they are full of life, of solitude, of melancholy, of innate grandeur, of concentrated spirit. They are almost never history. Yet they almost never cease being history."[5] Magical realism—attributed by André Breton to the Mexicans—is not invoked here, though the term has been applied to Meyer's new work. Isn't it just another effect of cultural colonization that we perceive anything that has not been prepackaged by Hollywood as extravagant or surreal? In *Espejo de Espinas* we witness pure verification of experience, of the personal, and a transparent display of content. In *Truths & Fictions*, Meyer moves toward a more refined process of dramatization, in which the narrative quality frequently coincides with that of the revolutionary murals of Diego Rivera, José Clemente Orozco, and David Alfaro Siqueiros.

Another artist's work serves as an equally important reference: the photomontages of Josep Renau. A republican activist, Renau went into exile in Mexico at the end of the Spanish Civil War. Between 1947 and 1966 he produced his cycle of photomontages *The American Way of Life*, extracting images and text from *Life*, *Fortune*, and the *New York Times*. Much of Frank's *The Americans*, like *The American Way of Life*, attempted to uncover the illusion of the "American dream" and to bring to light the desolation and sordidness that was buried underneath. Renau, like John Heartfield, pretended to surpass the latent ambiguity in photography and accurately address the strength of its meaning through the articulated rhetoric that photomontage permitted. When straight photography can't penetrate the armor of the real, "photomontage," says Renau, "is a form of seeing reality with X rays. It is the only way to make the spectator see how absurd it is to get two levels of existence to coincide in the same space. This is what I call authentic realism."[6] If Heartfield offered an X ray of the Republic of Weimar and the rise of Nazism, if Renau made an X ray of McCarthyism and the witch hunt, it is sure that Meyer X rays the era of Reagan-Bush and the lagging capitalism that economists and political scientists call post-Fordism (the welfare state, hyperindustrialization, complete capitalization of society, diffusion of mass consumption, flexible labor relations, and so on).[7]

THE PARADOX AS A RHETORICAL TACTIC

Clearly there are stylistic differences between Meyer and Renau, both expressive and technical. The two artists benefit from the cut-and-paste procedure, but one uses scissors

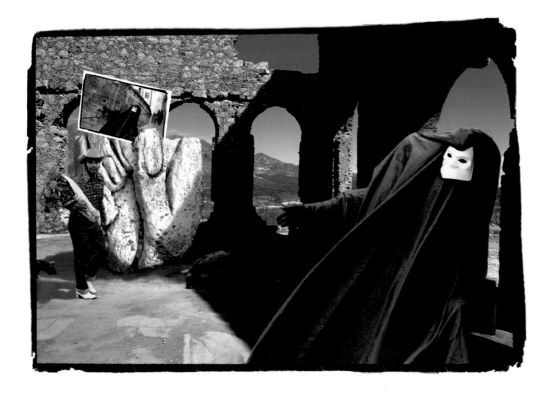

VISITATION, 1980/94

logical obsession. On the other hand, it challenges us to remain alert; it trains us to be on the lookout for other possible paradoxes hidden in the world that surrounds us.

If it is impossible to believe in these images completely, if it is impossible to accept at first glance the evidence that they seem to provide—since Meyer's deliberate fair of confusion uses all means to discourage such a reading—it is equally impossible to return them to the faraway world of fiction. They are images that are situated in an ambiguous neutral space, as illusory as they are present: the *vrai-faux*, the space of uncertainty and invention—the most genuine category of contemporary sensibility. Today more than ever, the artist should reclaim the role of demiurge and seed doubt, destroy certainties, annihilate convictions, so that from the chaos that is generated, a new sensibility and awareness may be constructed.

NOTES

1. "Una hora con el Generalísimo." Interview with Francisco Franco by Marqués de Luca de Tena, ABC (Seville), July 18, 1937.

2. Foucault, Michel. *L'Archeologie du savoir*, Paris: Gallimard, 1969, pp. 14–15.

3. *International Center of Photography Encyclopedia of Photography*, New York: Crown, 1984, p. 150.

4. Trinh, T. Minh-ha. "Documentary Is/Not a Name." *October* 52, Spring 1990, pp. 76–98.

5. Monsiváis, Carlos. Introduction, in *Espejo de Espinas*, by Meyer. Mexico: Fondo de Cultura Económica, 1986, p. 9.

6. Quoted in Carole Naggar, "The Photomontages of Josep Renau." *Artforum*, Vol. XVII, Summer 1979, p. 36.

7. Hirsh, Joachim and Roland Roth. *Das neue Gesicht des Kapitalismus. Vom Fordismus zum Post-Fordismus*, Hamburg: EUA Verlag, 1986.

and glue while the other uses computer-imaging technology. Renau juxtaposes symbol-images that will yield an unexpected statement; he is interested in the shock and strength of the message. Meyer, faithful to his training as a photojournalist, reconstructs the illusion of real space; no one will notice his alteration, performed with scalpel precision. As for content, his job is subtler and is based fundamentally on paradox. What's more, sometimes this paradox doesn't even need to be constructed, because it already exists within the same reality. That's why some of the photographs in *Truths & Fictions* have not suffered any alterations; they are perfect instances of found paradoxical situations, true surrealist objets-trouvés that a reality saturated with contradictions presents: the blunders of reality overcome fantasy, life imitates art. This coexistence of direct snapshots with altered photographs indicates the extent to which digital retouching constitutes for Meyer a consciously elected methodology and not merely a techno-

Translated from Spanish by Dalia Rabinovich

What of the photograph made out of nothing? What about painting with light?
Is it photography? Surely if we can paint with light we can paint with dreams, create the
morning mist or the afternoon glow. Is it a fake? Hardly. Whatever else may
be false in this tenuous existence of ours, imagination is not. All that we value, that we
strive to uphold, all that gives us strength, has been made of dreams, and we must dream
on. If pixels be the vehicle that realizes our dreams, be it so.

SHAHIDUL ALAM, PHOTOGRAPHER, BANGLADESH

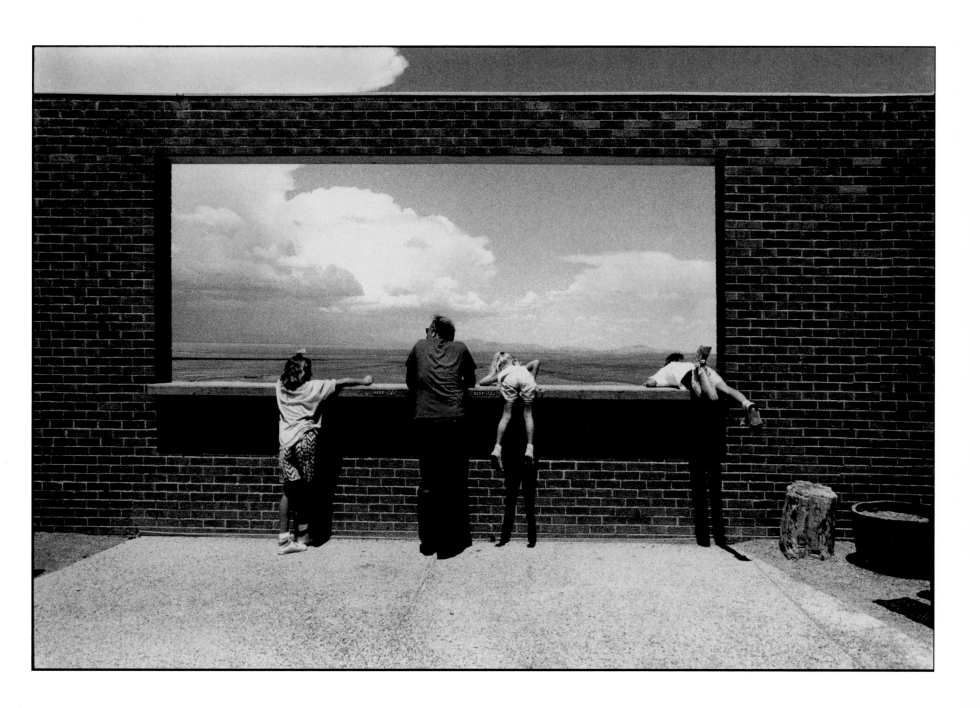

WINDOW ON WINSLOW, WINSLOW, ARIZONA, 1990

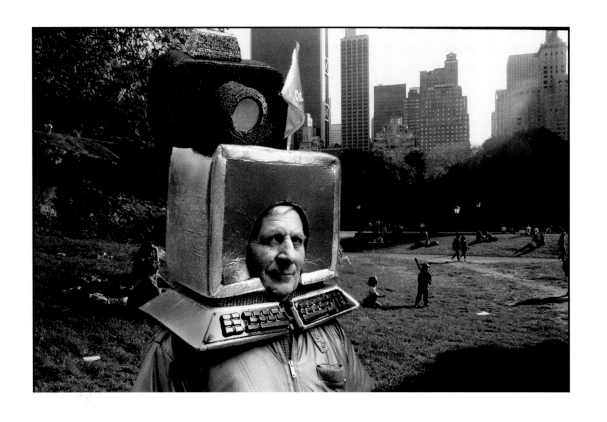

WALKING BILLBOARD, NEW YORK CITY, 1987/93 ▲
"FREEING FILM," NEW YORK CITY, 1987/93 ▶

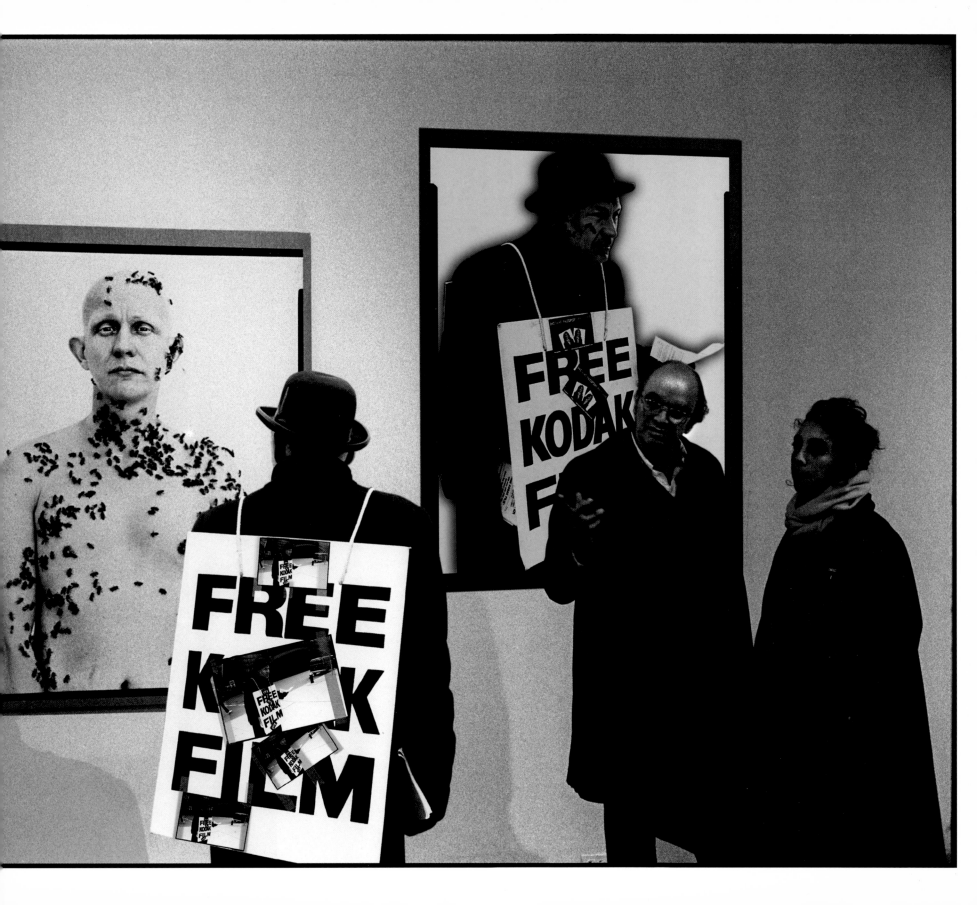

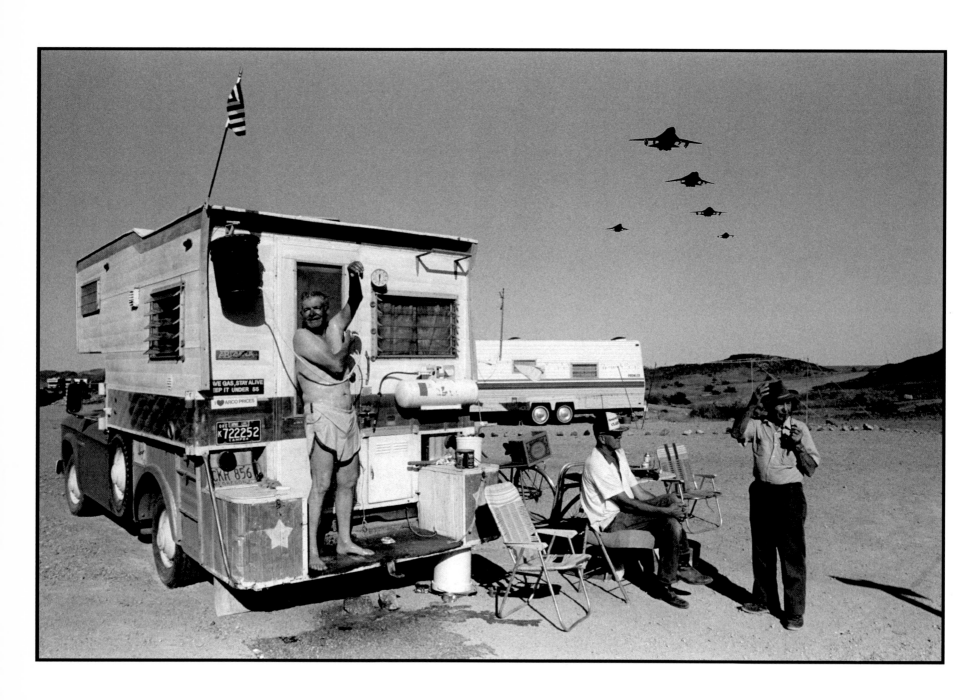

DESERT SHOWER, YUMA, ARIZONA, 1985/93

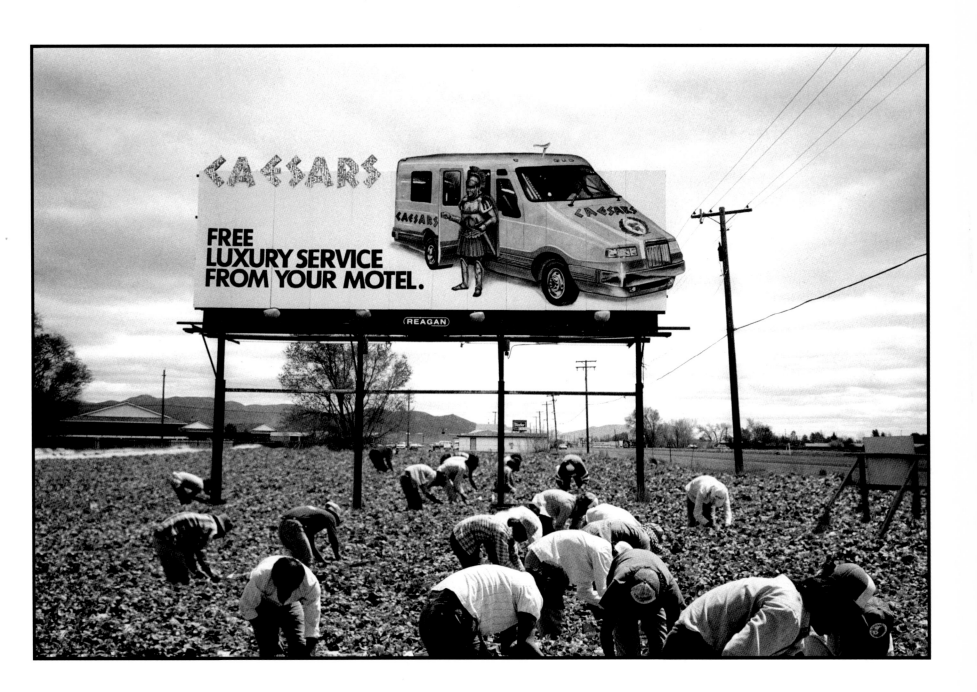

MEXICAN MIGRANT WORKERS, HIGHWAY IN CALIFORNIA, 1986/90

"BOYS WILL BE BOYS . . . ," NEW YORK CITY, 1989

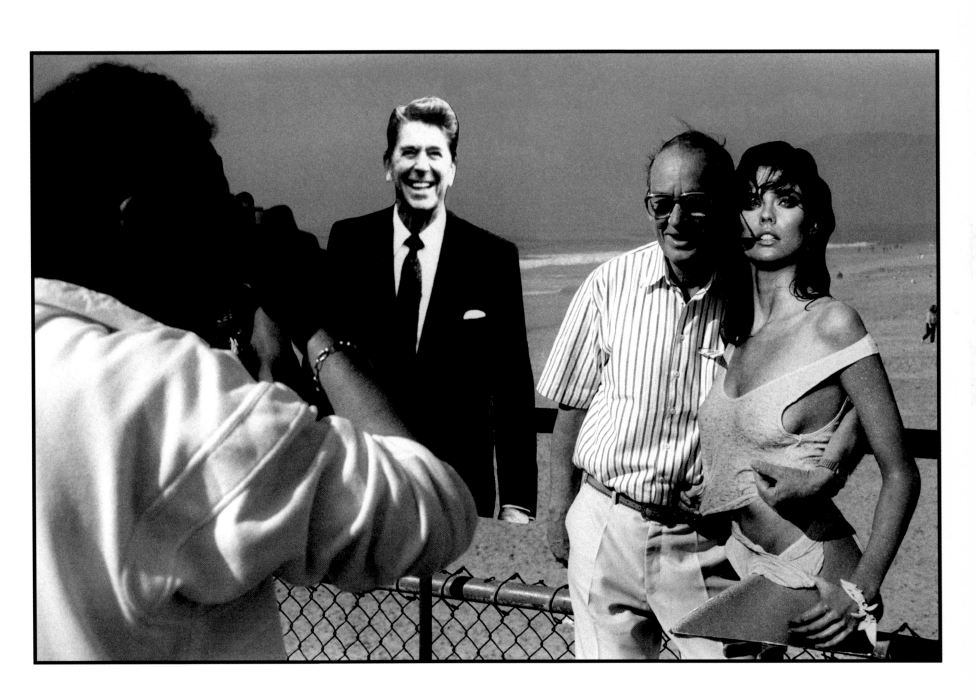

CARDBOARD PEOPLE, MALIBU, CALIFORNIA, 1988

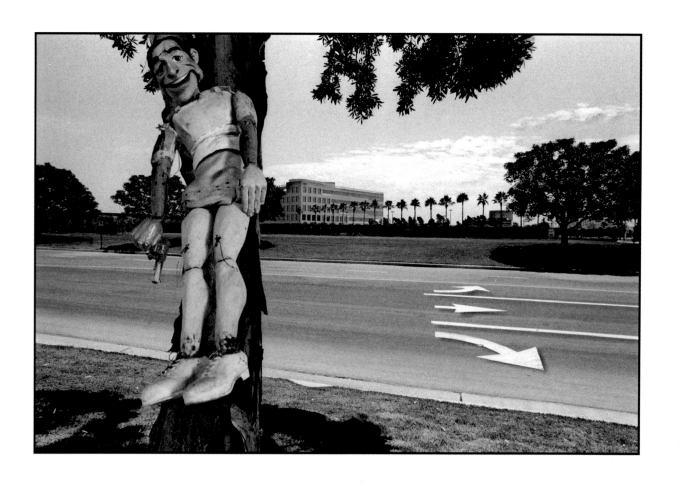

REPUBLICAN TERRITORY, ORANGE COUNTY, CALIFORNIA, 1989/93 ▲
PLANTATION, EL CENTRO, CALIFORNIA, 1987/92 ▶

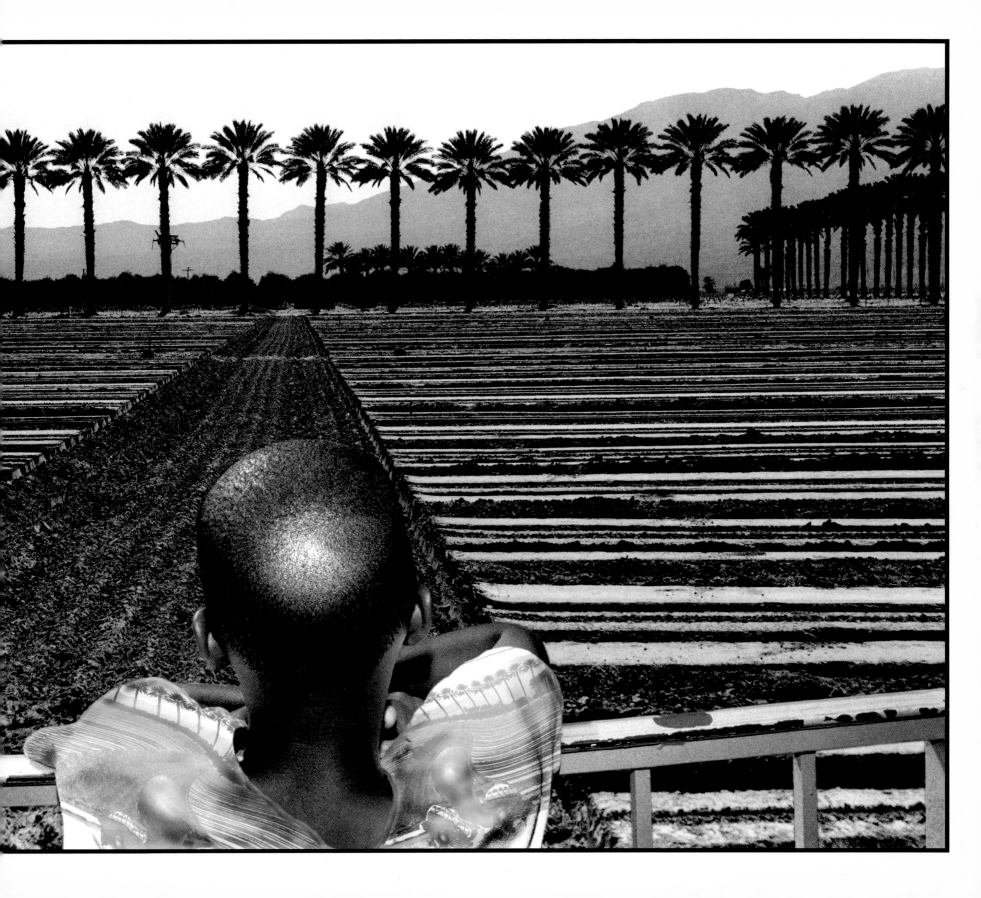

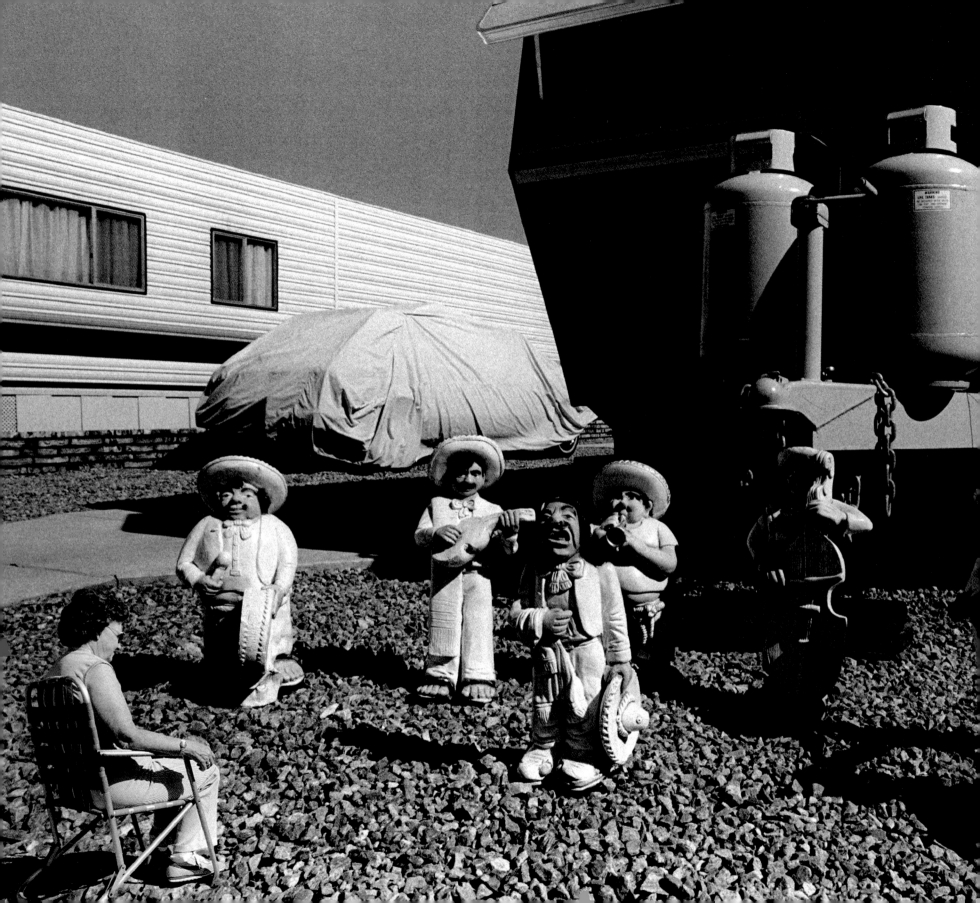

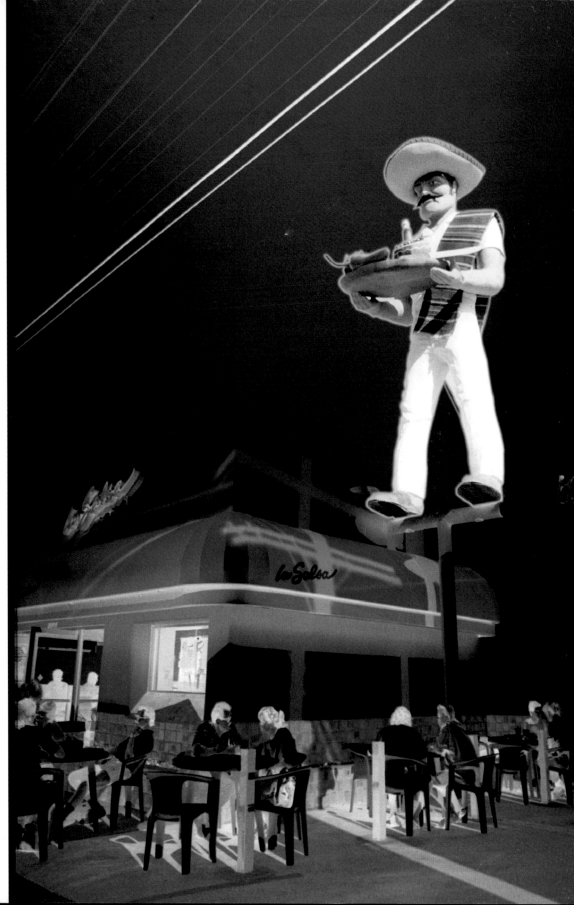

The brave new world I envisioned growing up during the Second World War was one of justice triumphing over the forces of evil, and then we would all return to the task of creating a nation that Buck Rodgers would be proud of. We did that, and then realized that Buck Rodgers was a WASP, spoke only English, and didn't have an accent.

CHARLES BIASINY-RIVERA, PHOTOGRAPHER
AND DIRECTOR OF EN FOCO INC., UNITED STATES

MEXICAN SERENADE, YUMA, ARIZONA, 1985/92, *page 24*
MEXICAN WITH A POSITIVE ATTITUDE
WITHIN A NEGATIVE ENVIRONMENT, MALIBU, CALIFORNIA, 1988/92, *page 25*

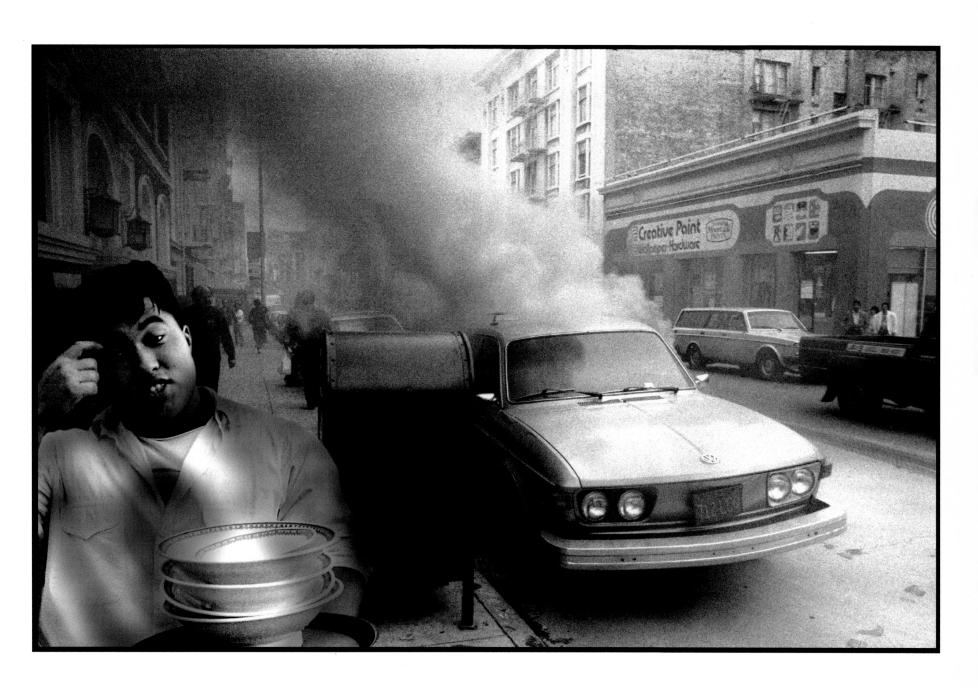

SMOKE GETS IN YOUR EYES, SAN FRANCISCO, CALIFORNIA, 1989/95

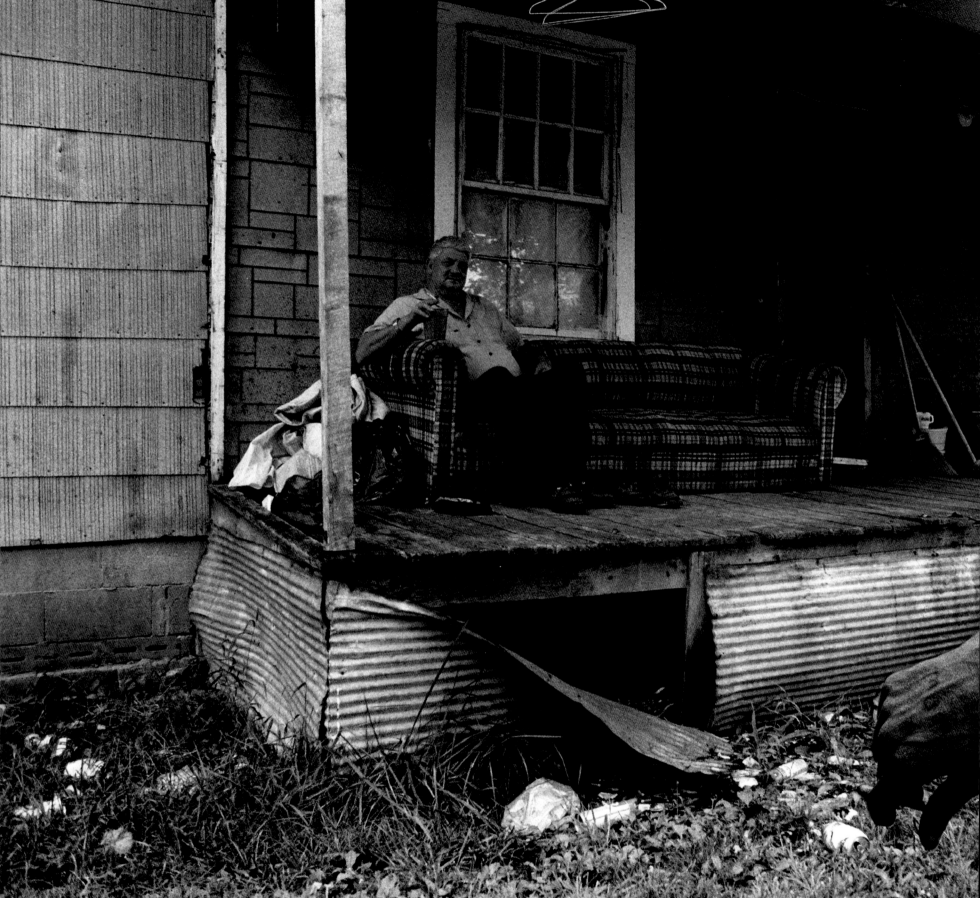

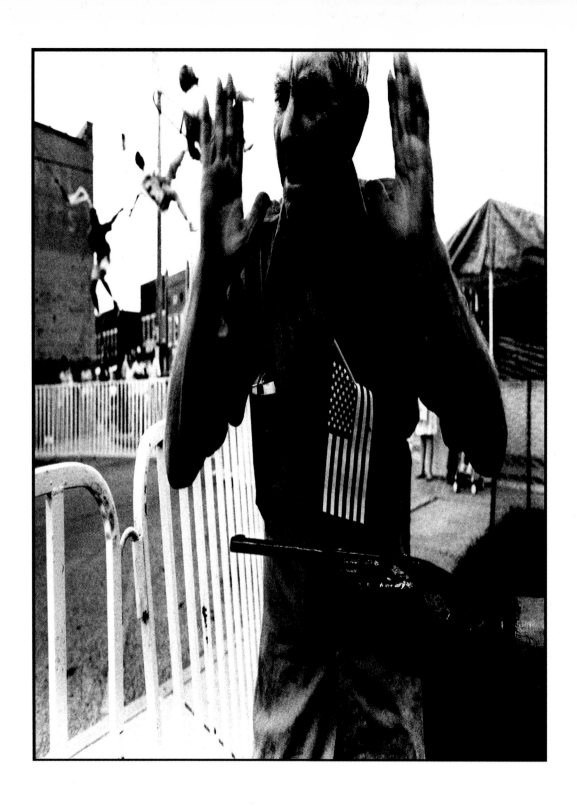

▲"WE'RE THE GREATEST," CAVE CITY, KENTUCKY, 1990/93
◄ VINCENT AND FREE BIRD, BOWLING GREEN, KENTUCKY, 1990/93

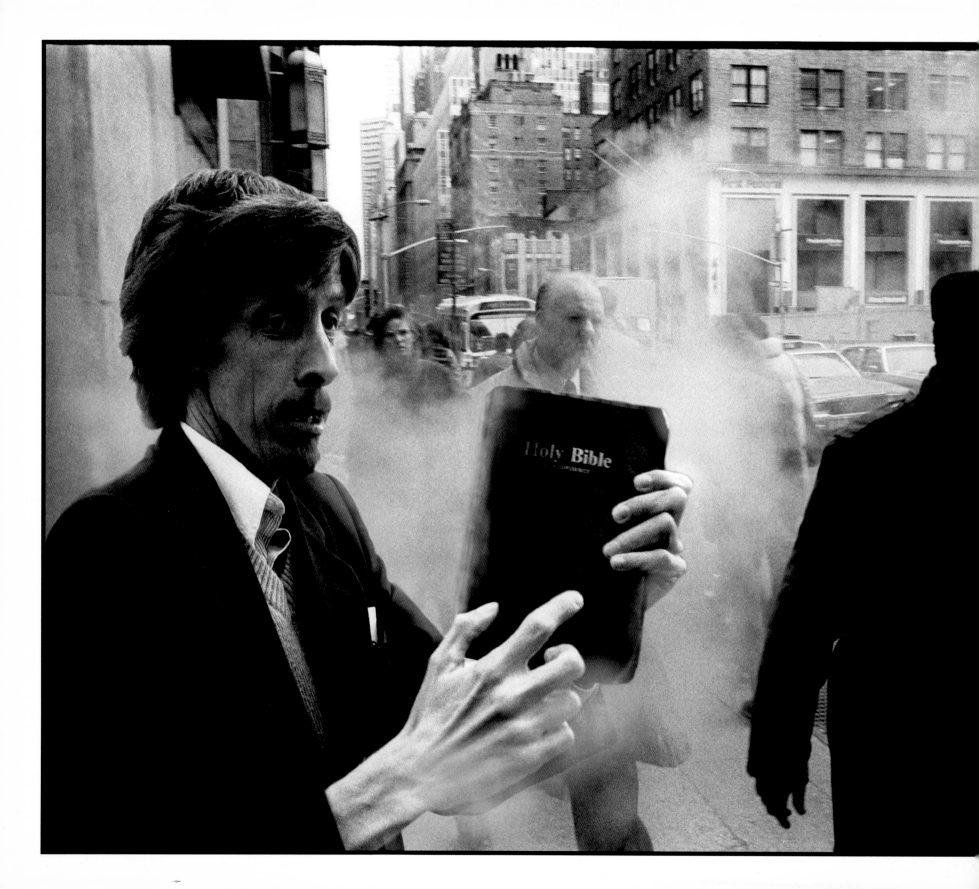

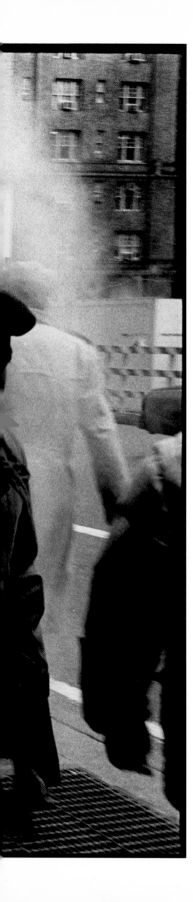

The urge to invent reality, like the need to describe it in an "objective" manner, is as old as the history of culture. The tendency toward fabrication shows that this need is rooted not only in accepting the fact that we are unable to describe reality "as it is" (even when using a faithful tool such as a camera), but also, perhaps, in that we are born with a strong urge to experience a more fascinating world.

AVRAHAM EILAT, ARTIST, ISRAEL

BIBLICAL TIMES, NEW YORK CITY, 1987/93

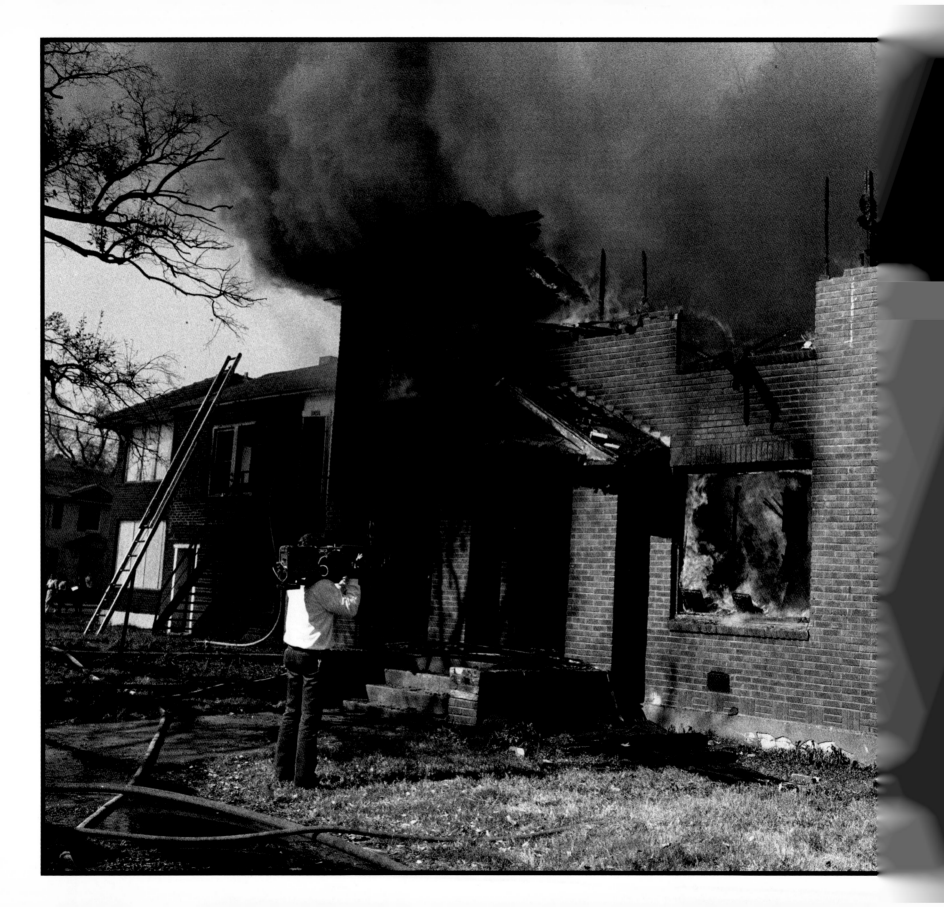

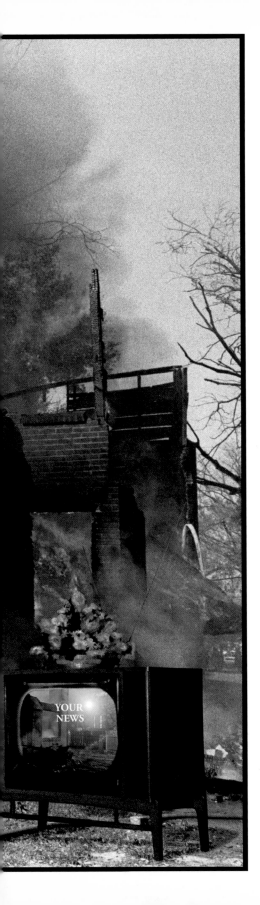

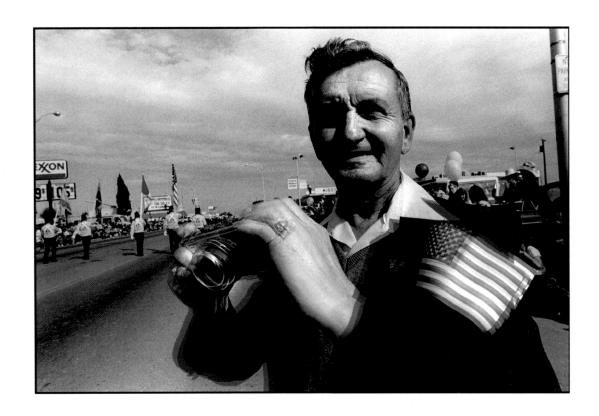

▲ ABOUT PHOTOGRAPHY, YUMA, ARIZONA, 1985/92
◄ THE FIVE O'CLOCK NEWS, HOUSTON, TEXAS, 1986/93

To complain that we are being rendered superficial by television or computers is
to ignore the great desire for superficial knowledge that existed long before television and
computers. Universal literacy was a mixed blessing, arguably good in the
economic sphere and in politics, though arguably less good elsewhere in human life.

JEROME TARSHIS, WRITER, UNITED STATES

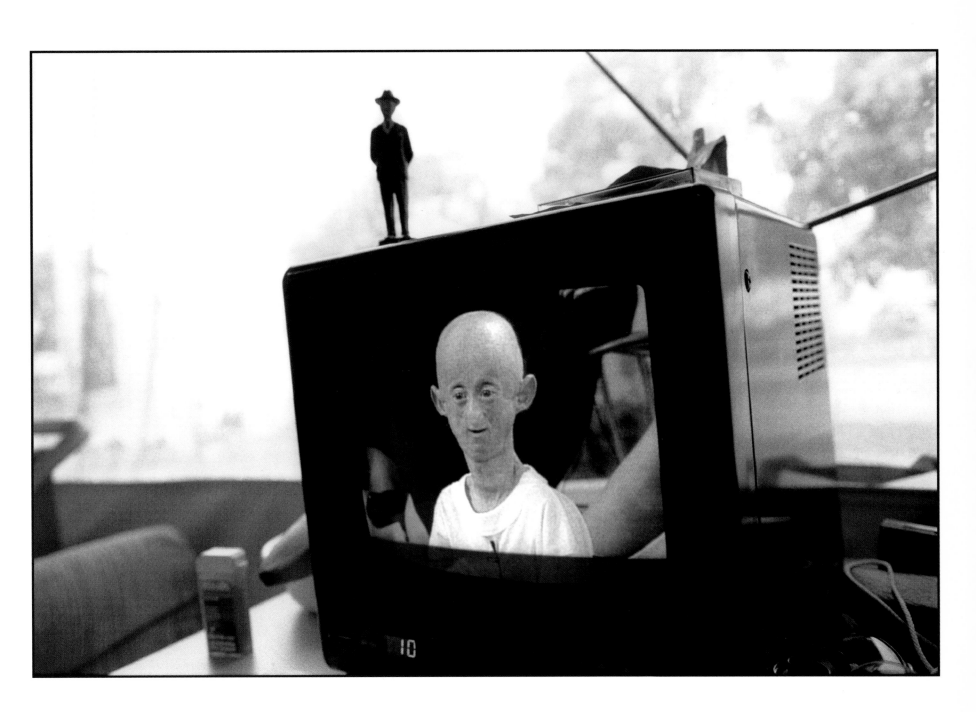

SAN JOSÉ GREGORIO AND THE *DONAHUE* SHOW, BOWLING GREEN, KENTUCKY, 1990

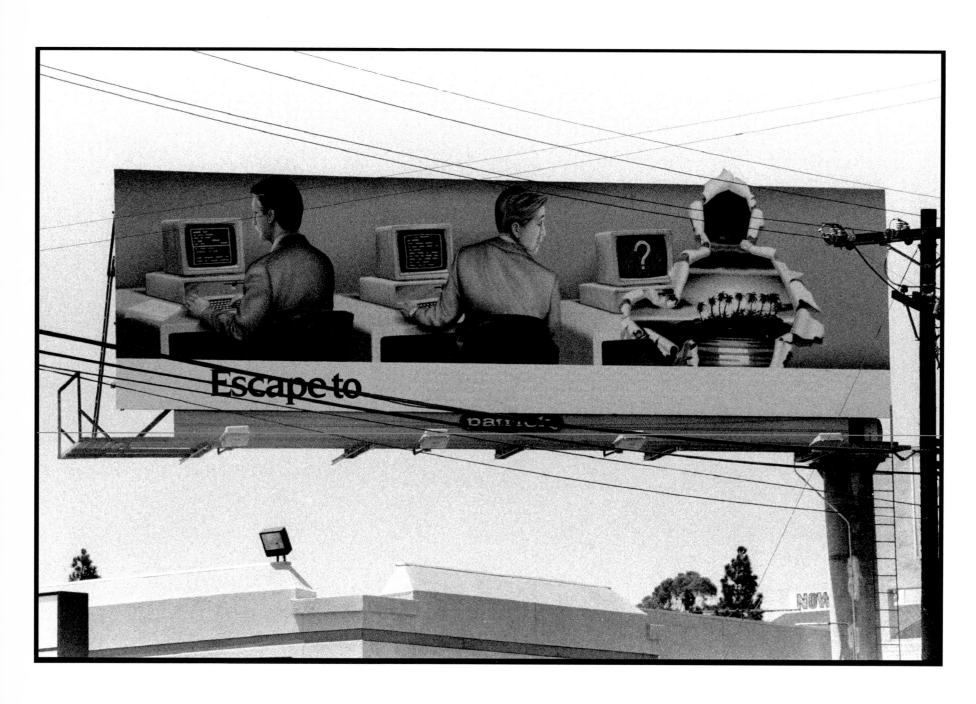

"ESCAPE TO . . . ," LOS ANGELES, CALIFORNIA, 1989/92

36

"WE'D LOVE TO HAVE YOU," HIGHWAY IN TEXAS, 1991/93

Reality? Never touch the stuff. There should be a government warning against it.

SYLVIA STEVENS, FILM DIRECTOR, UNITED STATES

MONUMENTAL CHAIR, WASHINGTON, D.C., 1989

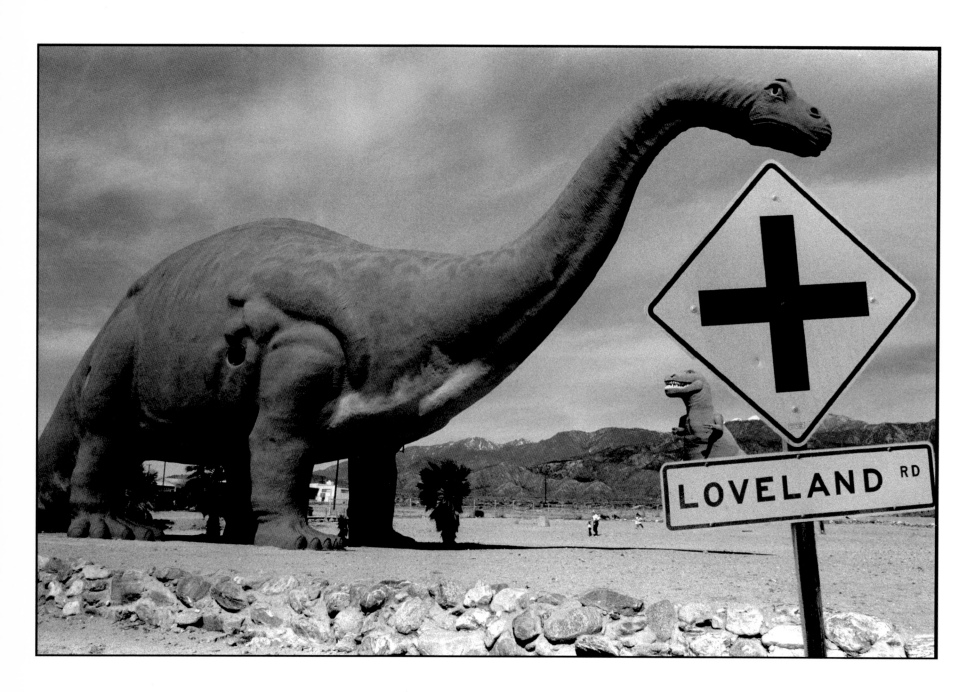

LOVELAND, ON THE ROAD IN NEW MEXICO, 1989/93

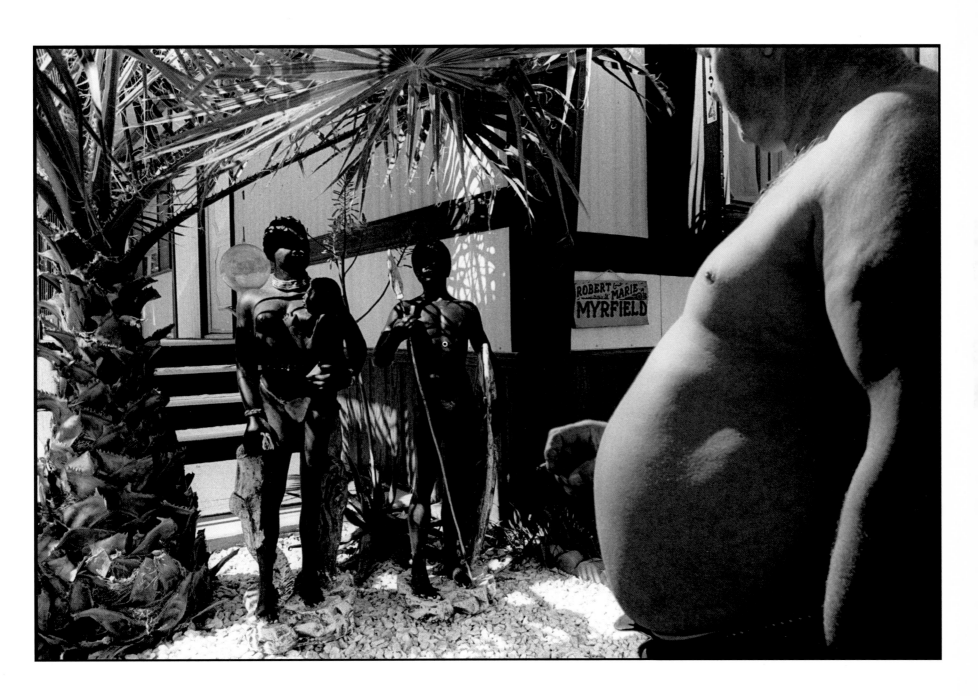

LITTLE BLACK TRIBE, YUMA, ARIZONA, 1985/92

41

It is fascinating to think that
all of human knowledge can be
expressed as an almost
infinite series of "Yes" and "No."

**DIEGO GOLDBERG,
PHOTOJOURNALIST, ARGENTINA**

EMOTIONAL CRISIS, TEXAS HIGHWAY, 1990/93

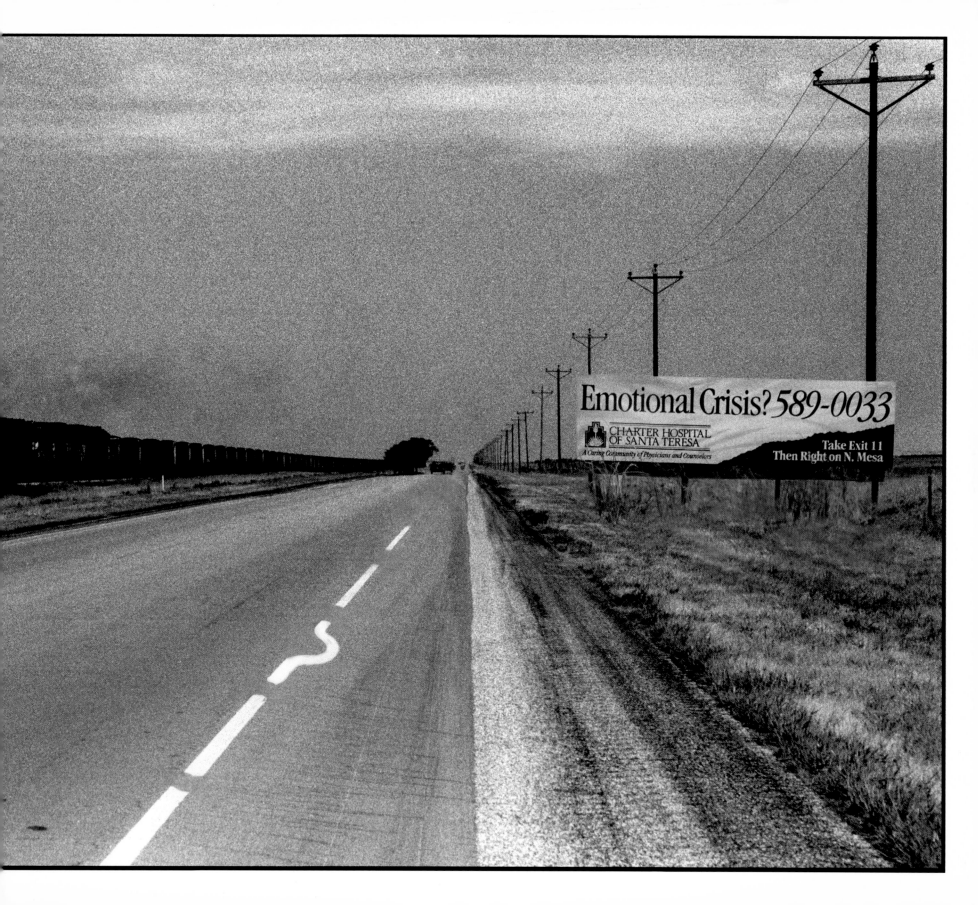

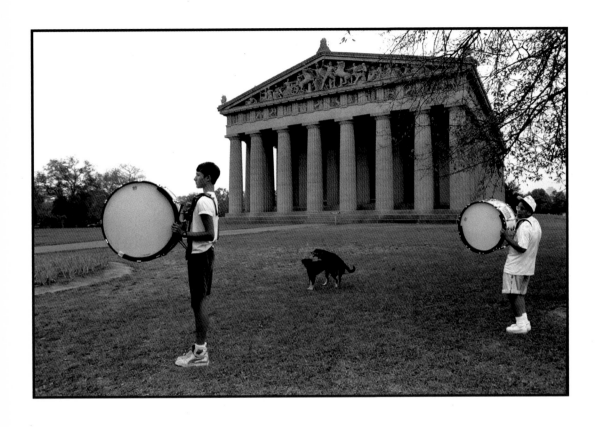

THE PARTHENON IN NASHVILLE, TENNESSEE, 1990/93 ▲
TIGHTROPE WALKER, KANSAS CITY, KANSAS, 1990/93 ▶

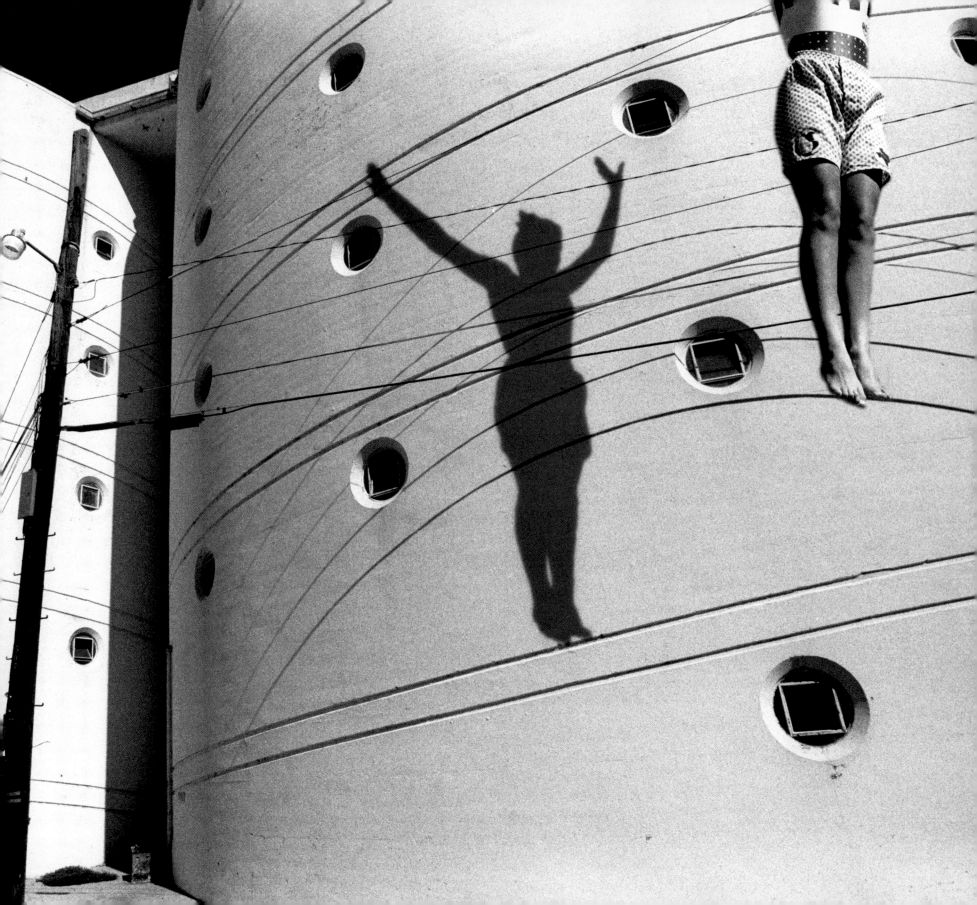

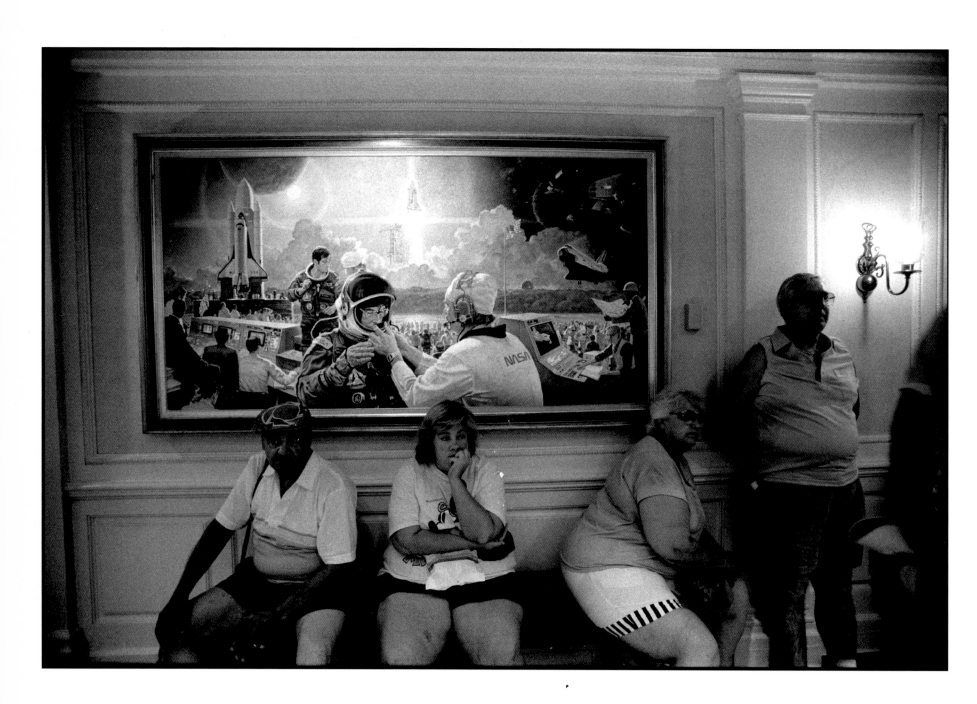

ASTRONAUTS, ORLANDO, FLORIDA, 1990

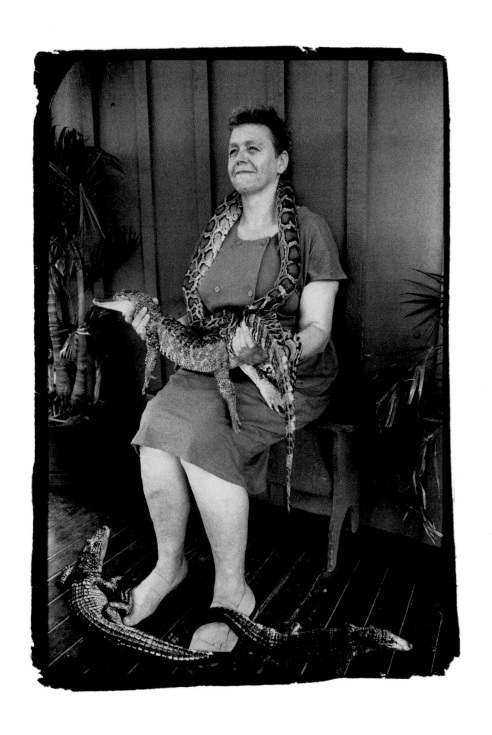

ENGLISH TOURIST IN FLORIDA, ORLANDO, FLORIDA, 1991/95

47

Photography can be a powerful mirror that shows us who and what we are and how we are changing. The evolution of social and psychological content must parallel that of photography's technical developments.

GEORGE KRAUSE, PHOTOGRAPHER, UNITED STATES

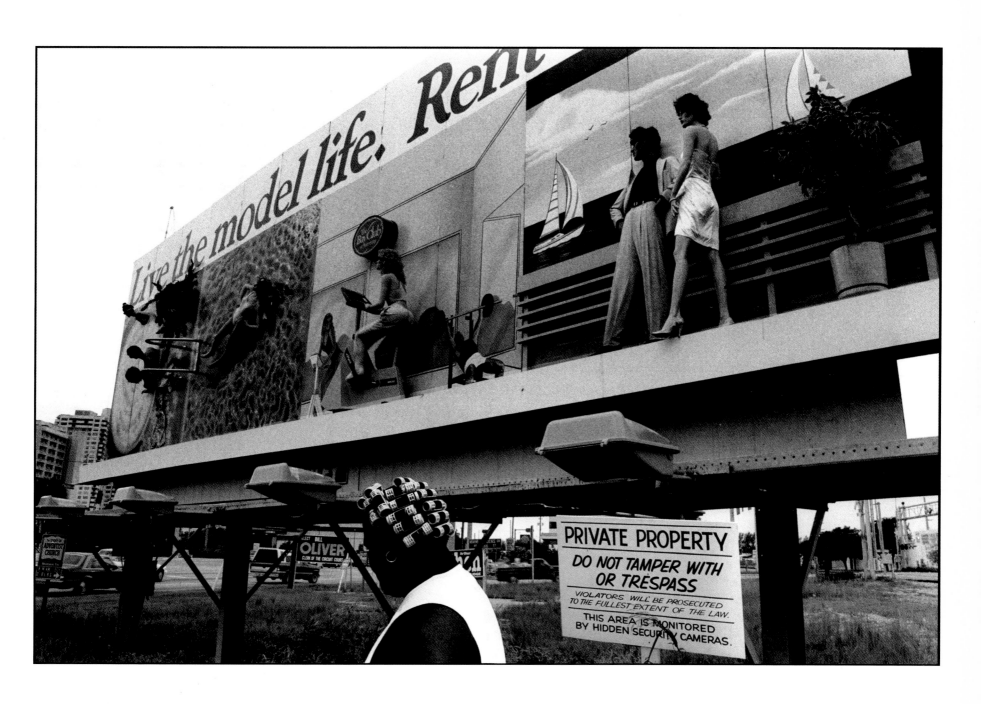

LIVE THE MODEL LIFE, MIAMI, FLORIDA, 1990/93

We now have a manic spin in our lives, more
and more, faster and faster. We might
think that things are basically the same, just
faster. But this spin itself creates some-
thing, an intense gravitational or magnetic field,
as it were.

Gravitation attracts other bodies, other force
fields, and generates fresh ideas, unanticipated
interactions—something new under the sun after
all. This is why artists should be exploring the
new technologies—to be there as it happens.

JIM STONE, PHOTOGRAPHER, UNITED STATES

THE NIGHT OF THE DAY OF THE DEAD
IN HOLLYWOOD, LOS ANGELES, CALIFORNIA, 1990/92

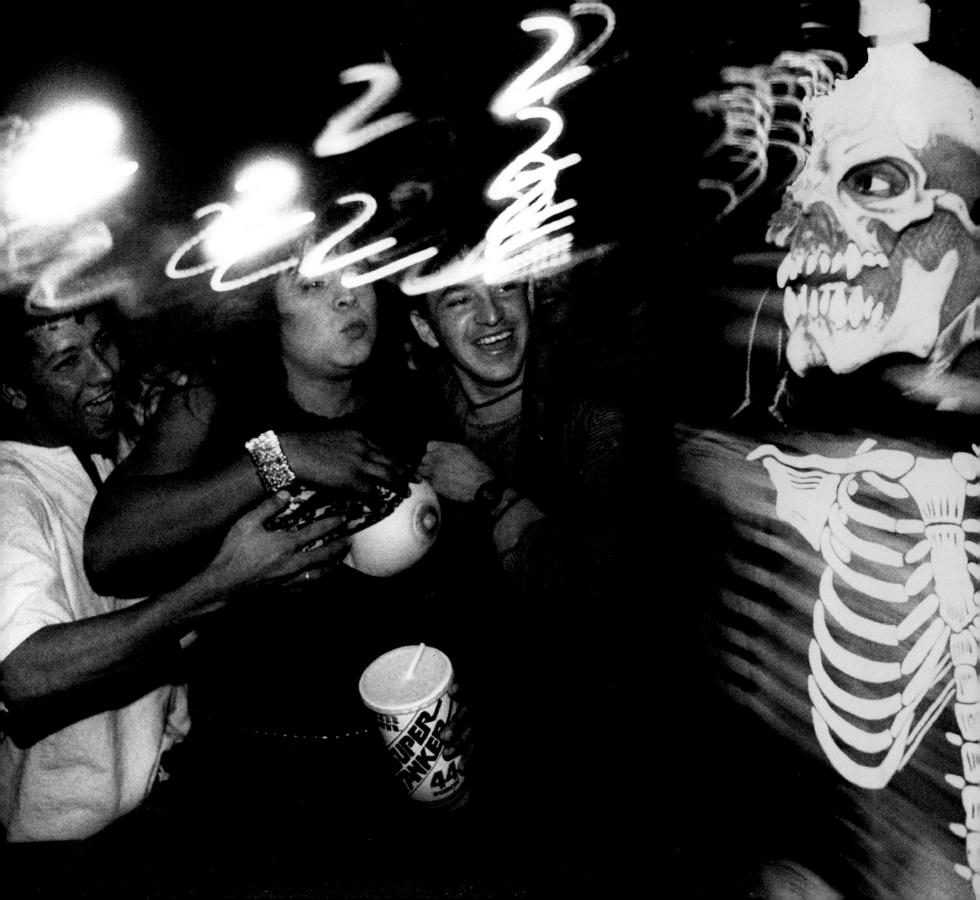

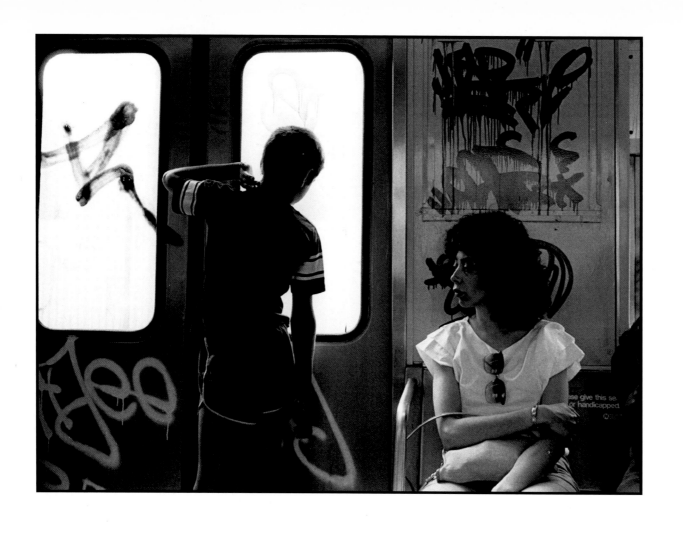

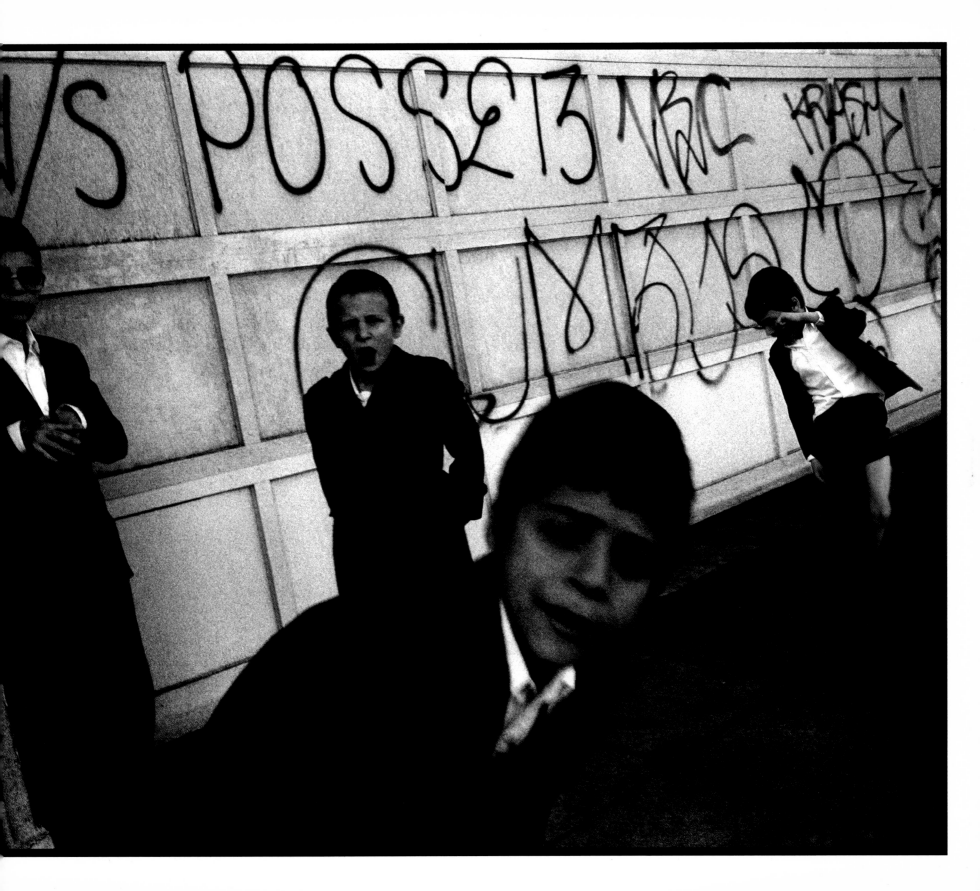

Once we enter the electronic screen, we will lose the familiar tactile surface of the photographic print (which will always remain closed in the privileged garden of the art of the past), and acquire—thanks to the concurrence of electronic images and sounds, sensations and, perhaps, olfactory suggestions—a new and different rapport with the image. . . .

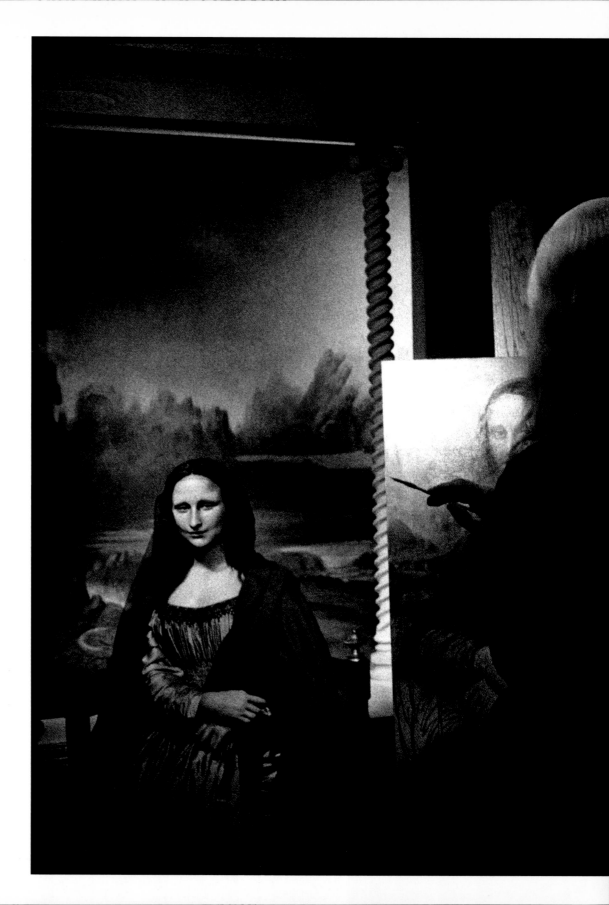

MONA LISA IN THE WAX MUSEUM,
SAN FRANCISCO, CALIFORNIA, 1986

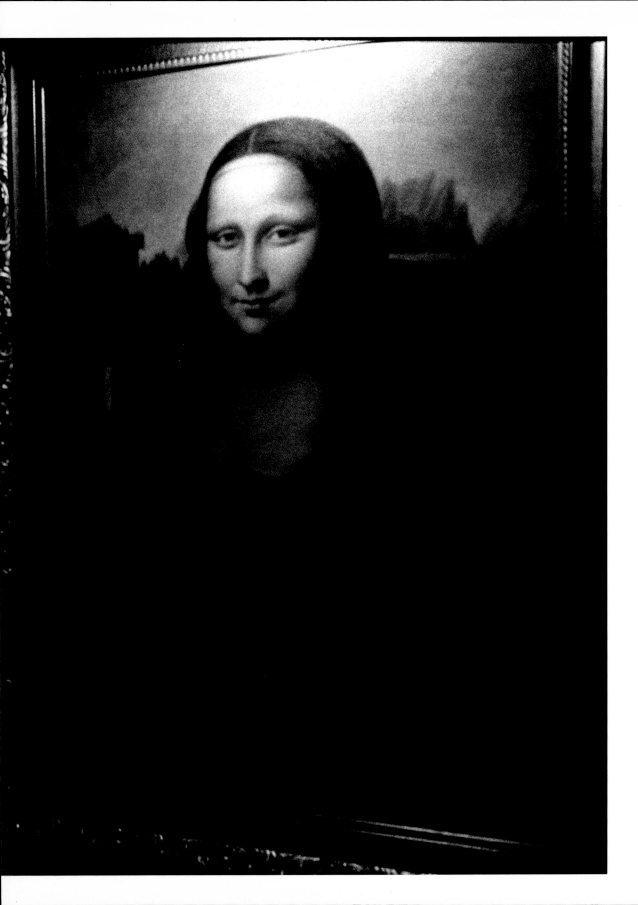

For my part, I still prefer to plunge my hands into a great pile of photographs on tangible paper, perhaps running the risk of crumpling a print or two, but in recompense enjoying the sensual pleasure of the vibrations of well-printed black and white or of an intense color.

**LANFRANCO COLOMBO, FOUNDER
AND DIRECTOR OF THE GALLERY
IL DIAFRAMMA-KODAK CULTURA, ITALY**

REVIVAL MEETING IN TIMES SQUARE, NEW YORK CITY, 1987/93 ▲
A DEVIL IN NEW YORK CITY, 1985 ▶

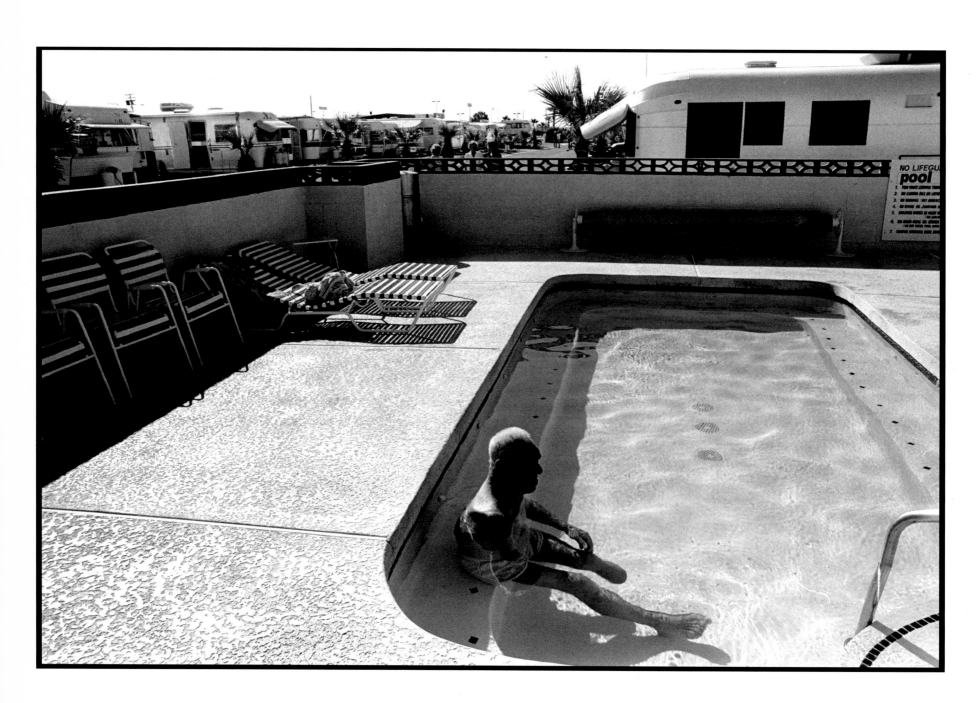

RETIREMENT COMMUNITY, YUMA, ARIZONA, 1985/92

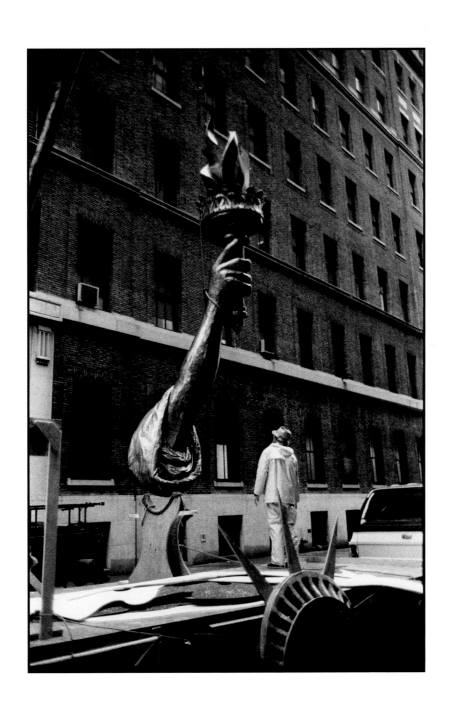

FRAGMENTED LIBERTY, NEW YORK CITY, 1987

As long as "seeing" is related to "knowing," it seems logical that there
will always be a need for representation which originates in a "seeing tool"
or camera. In other words, even though photographs are little more than
visual statements of various opinions, they at least allow us to ask
questions regarding the relationship between what is "real" and what
is expressed or believed. If the day comes when cameras are viewed
as peripheral to the tools of alteration (computers), the validity of that
dialogue will change, and so will our perception of what "is."

TIM BRADLEY, PHOTOGRAPHER, UNITED STATES

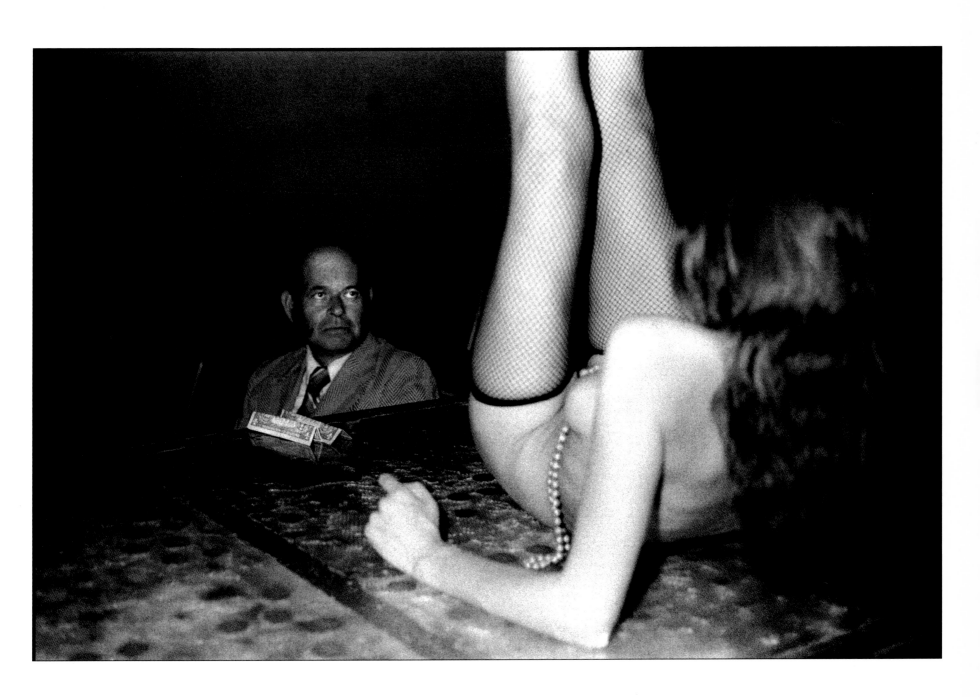

EYE BAR, LOS ANGELES, CALIFORNIA, 1980

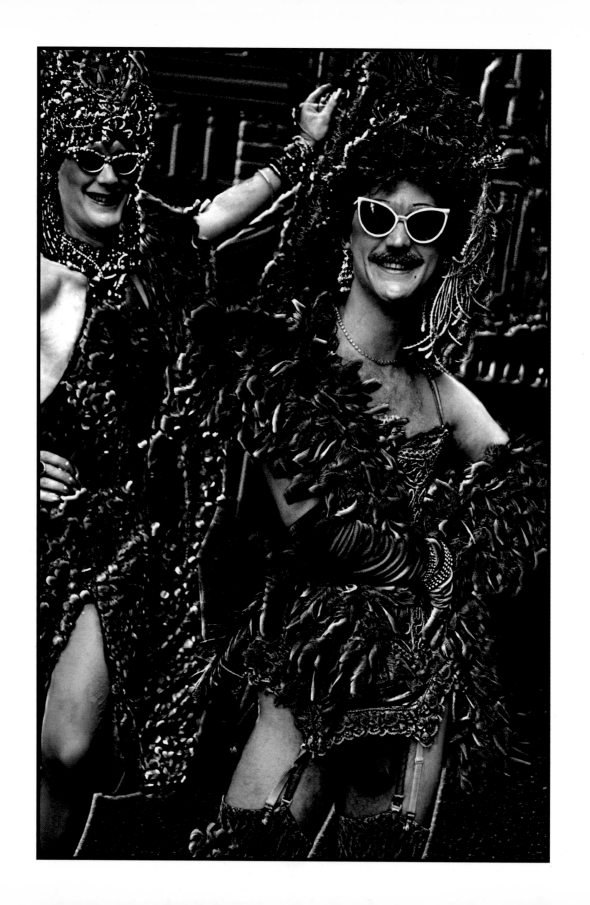

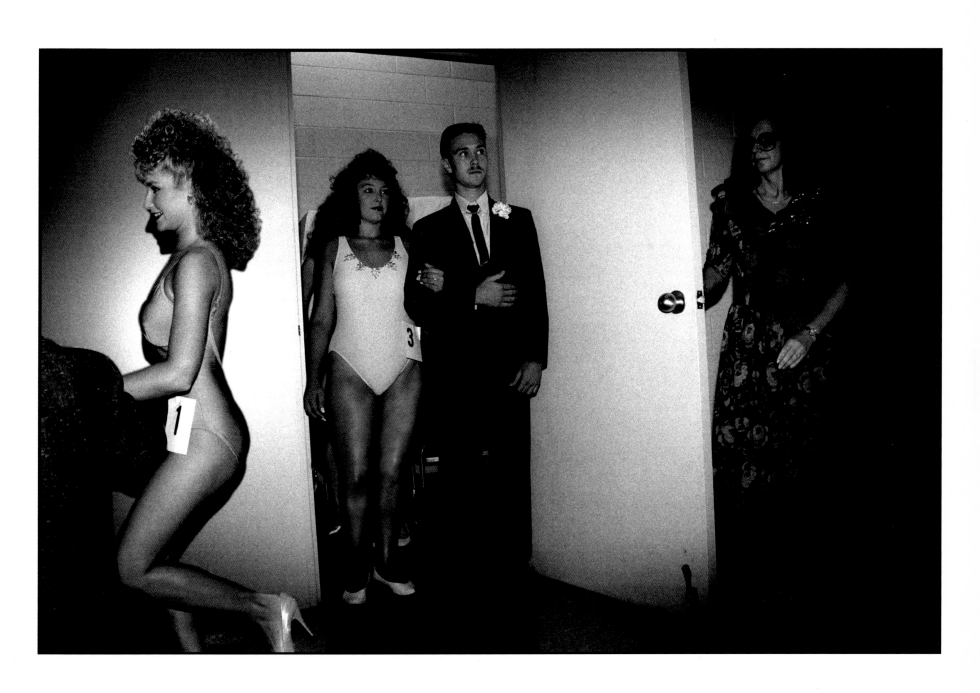

▲ CONTESTANT #3, CAVE CITY, KENTUCKY, 1991/93
◄ QUETZALCOATL, NEW YORK CITY, 1987/93

You remember the scene from *Fahrenheit 451* when all the old traditionalists hid away in the forest reading books? I am beginning to salt away random black-and-white prints, in plain, brown cardboard boxes, waiting for the call to flee.

COLIN JACOBSON, PICTURE EDITOR, ENGLAND

"YOU'RE DEAD . . . ," SAN DIEGO, CALIFORNIA, 1988/90

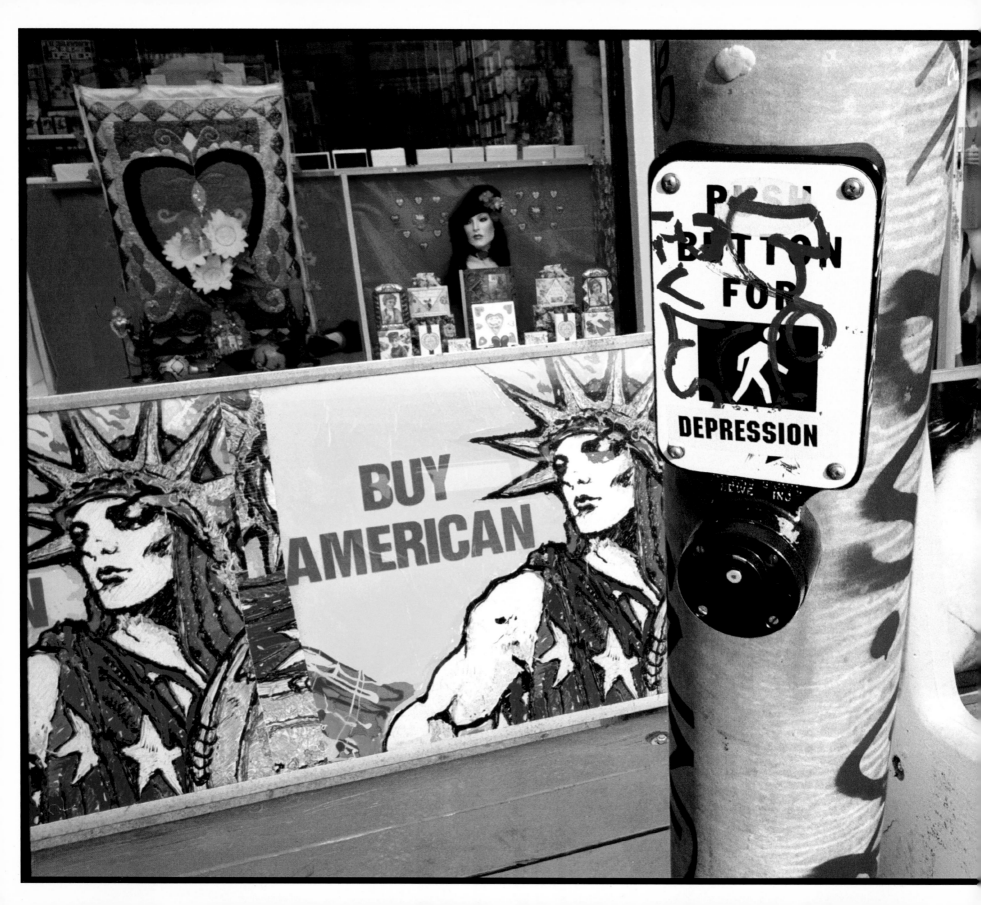

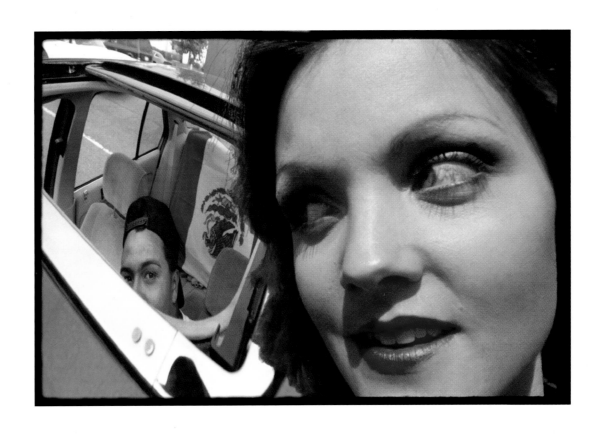

▲ EAGLES, OXNARD, CALIFORNIA, 1980/95
◄ BUY AMERICAN, LOS ANGELES, CALIFORNIA, 1991/91

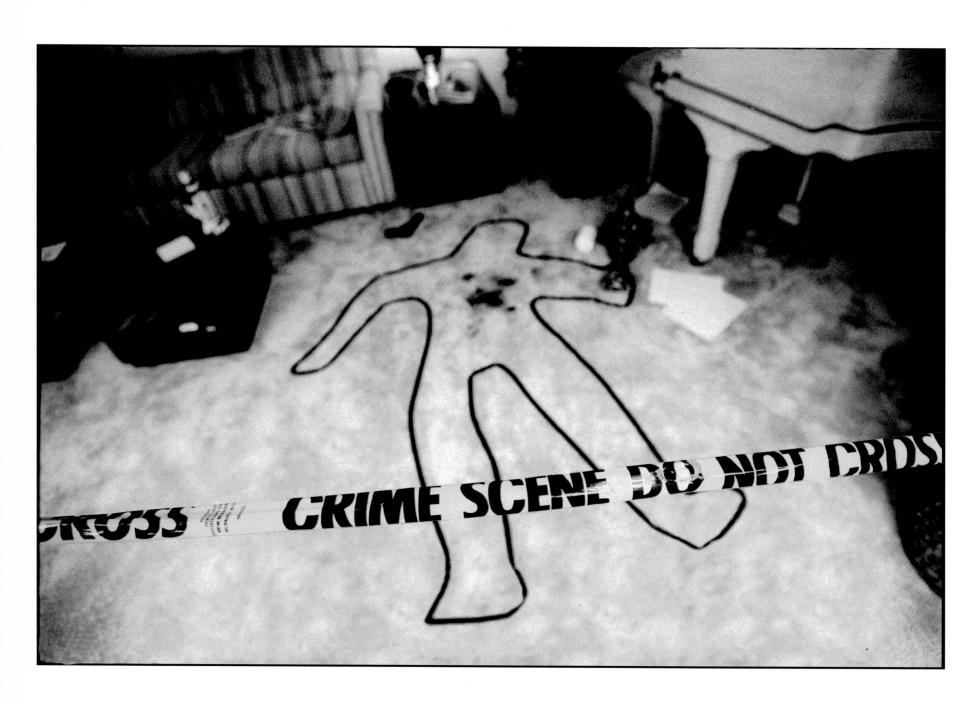

CRIME SCENE, MIAMI, FLORIDA, 1990/93

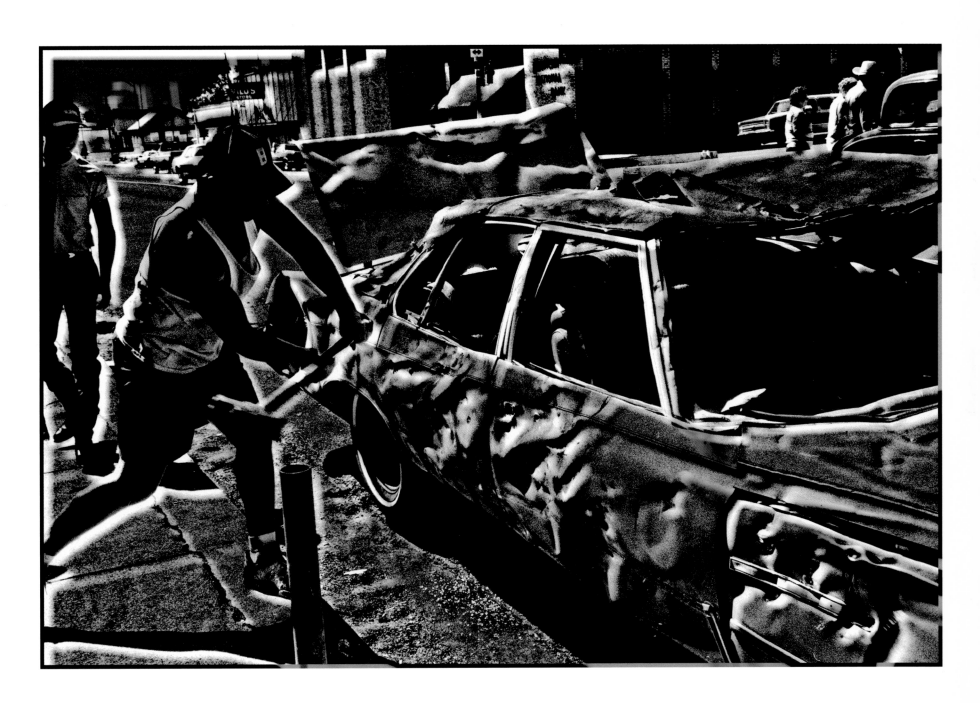

SOCIAL COMMENTARY, BAXTER SPRINGS, KENTUCKY, 1990/93

69

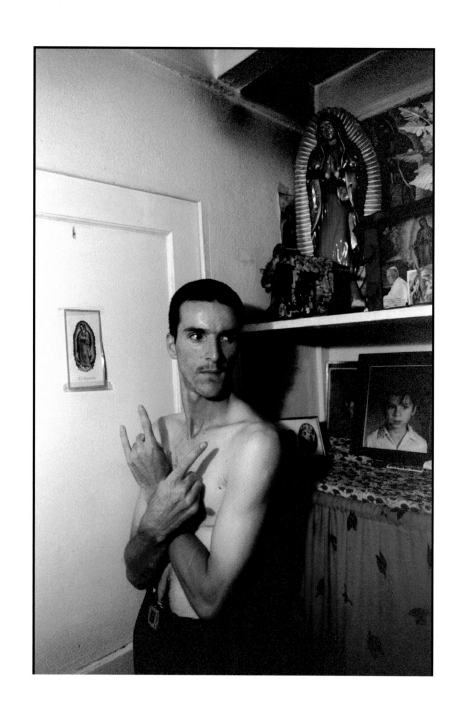

"BIG HAZARD," LOS ANGELES, CALIFORNIA, 1992/92

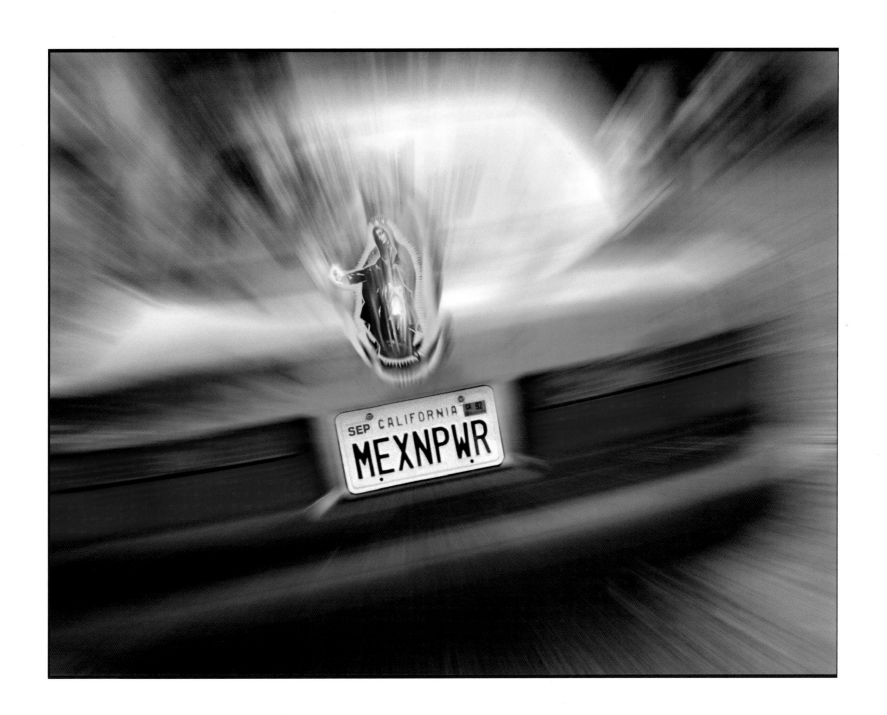

FROM CONQUEST TO RECONQUEST, OXNARD, CALIFORNIA, 1992/92

All this is illuminating and very positive, but the digital revolution also poses problems. On the one hand, there is the widening of the technological gap between the rich and the poor countries; on the other, the poorer countries are becoming technologically more dependent on the "developed" world.

CAMILO LUZURIAGA, FILM DIRECTOR
AND PHOTOGRAPHER, ECUADOR

AMERICANS WAITING TO ENTER THE OLMEC WORLD,
NEW YORK CITY, 1989/93

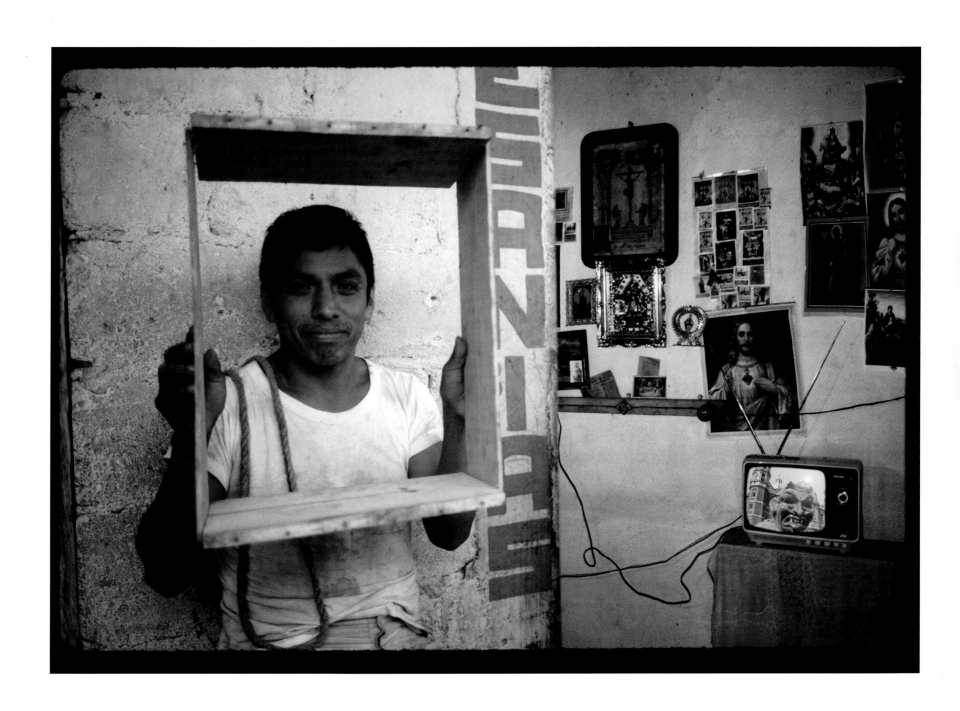

"LIVE BROADCAST . . . ," SAN JUAN MIXTEPEC, OAXACA, 1990/93

75

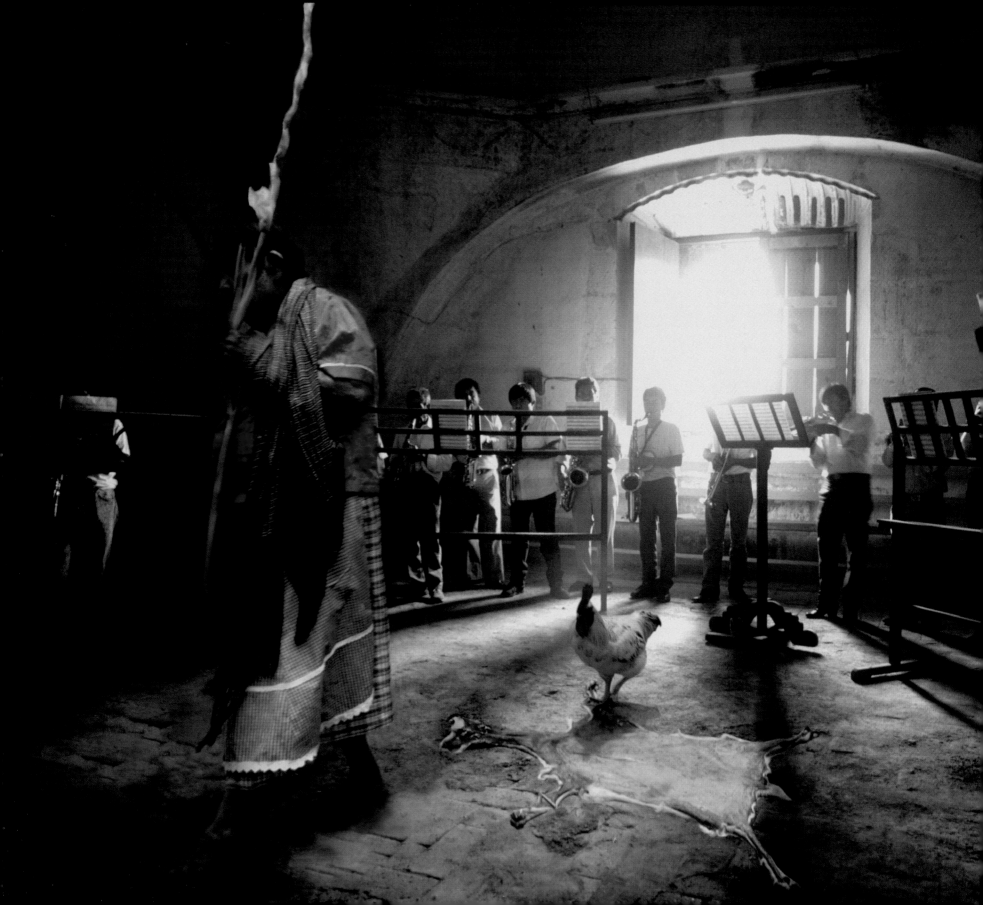

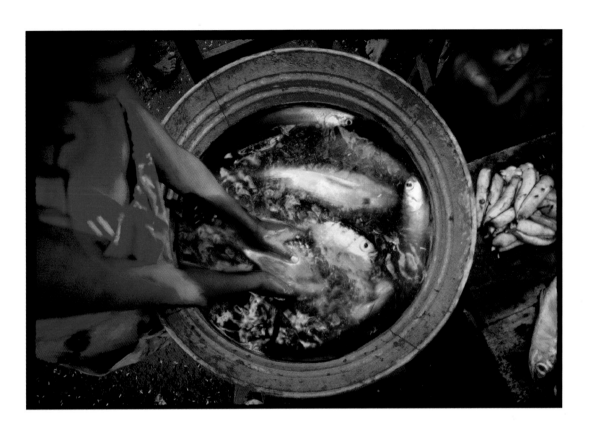

▲ PURIFICATION OF THE FISH, JUCHITÁN, OAXACA, 1987/93

◄ RITUAL WITH SHADOWS, TEOTITLÁN DEL VALLE, OAXACA, 1991/93

With the digital revolution, the photograph breaks its loyalty with what is real, that unique marriage between the arts, only to fall into the infinite temptations of the imagination. It is now more the sister of fantasy and dreams than presence.

VERONICA VOLKOW, POET, MEXICO

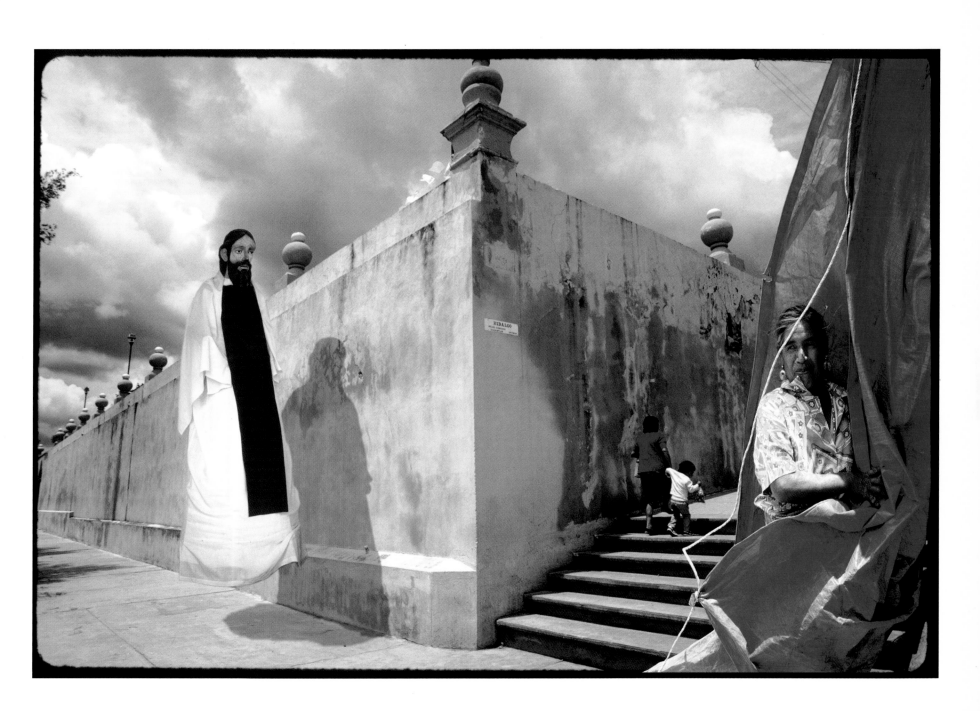

THE STROLLING SAINT, NOCHISTLAN, OAXACA, 1991/92

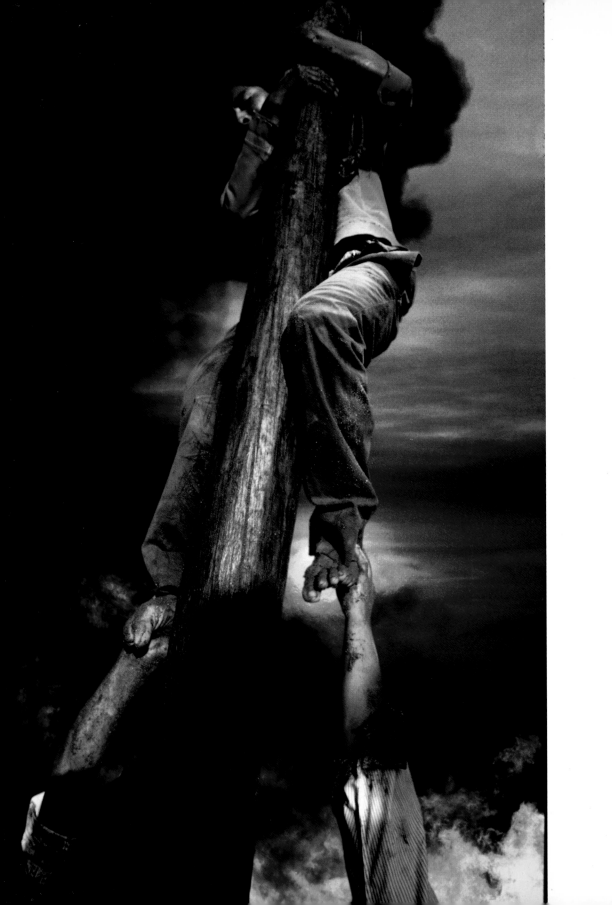

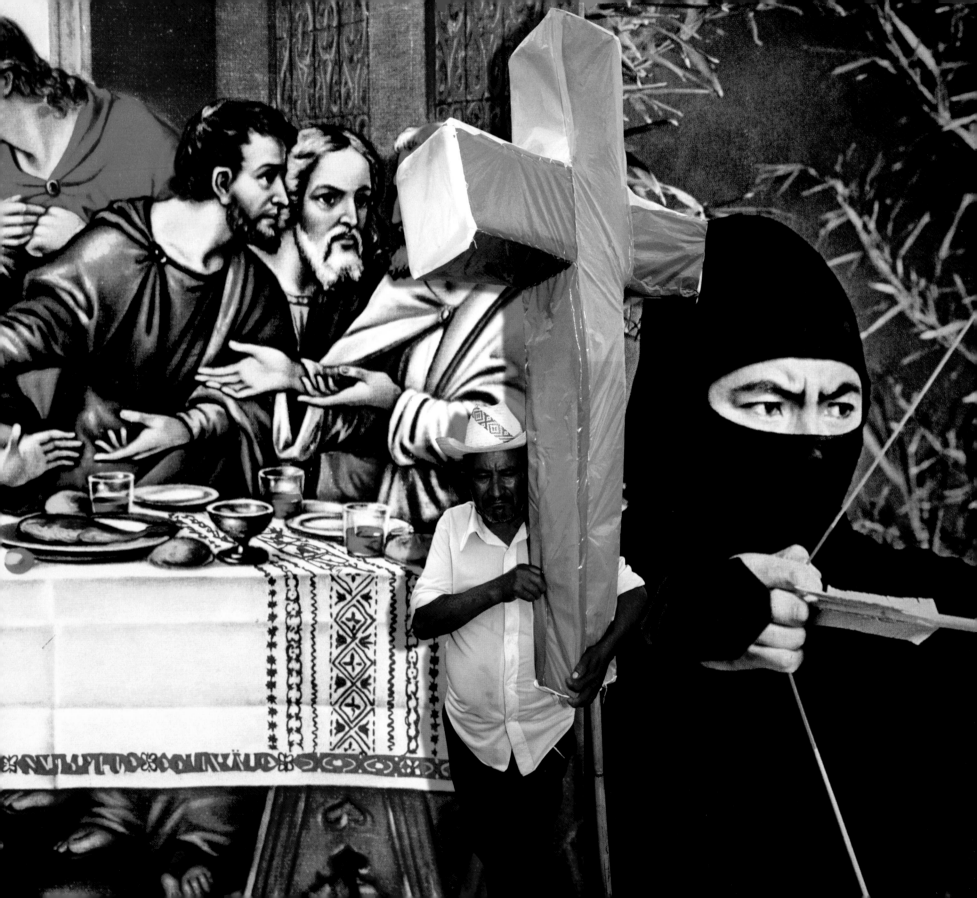

I write a great deal about the issue of spiritual memory, and I have begun to see technology not as the end of ceremony but rather, perhaps, as a partner in its new forms.

AMALIA MESA-BAINS, ARTIST, UNITED STATES

VIRGIL ON THE GREASED POLE, NOCHISTLAN, OAXACA, 1991/92, *page 80*
BLACK NINJA, NOCHISTLAN, OAXACA, 1991/93, *page 81*

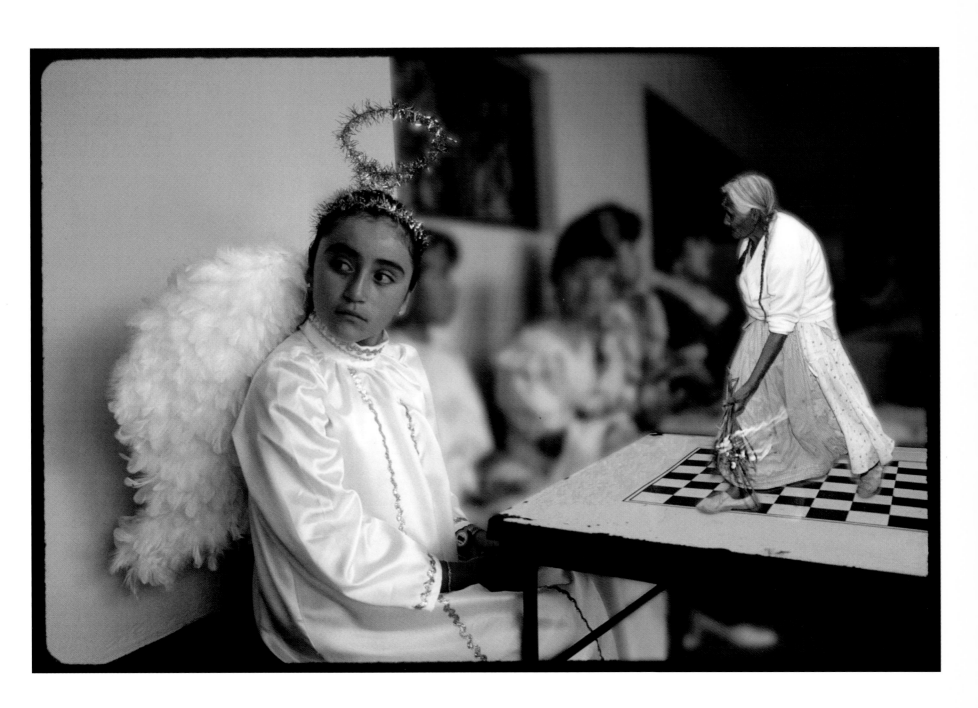

THE TEMPTATION OF THE ANGEL, 1991/91

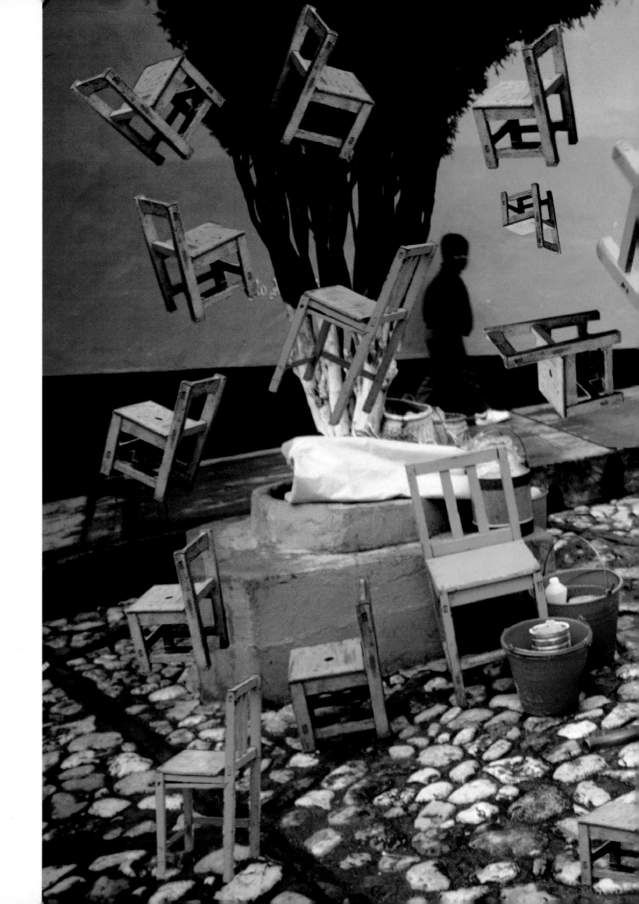

EXPLOSION OF GREEN CHAIRS,
TLAXIACO, OAXACA, 1991/93

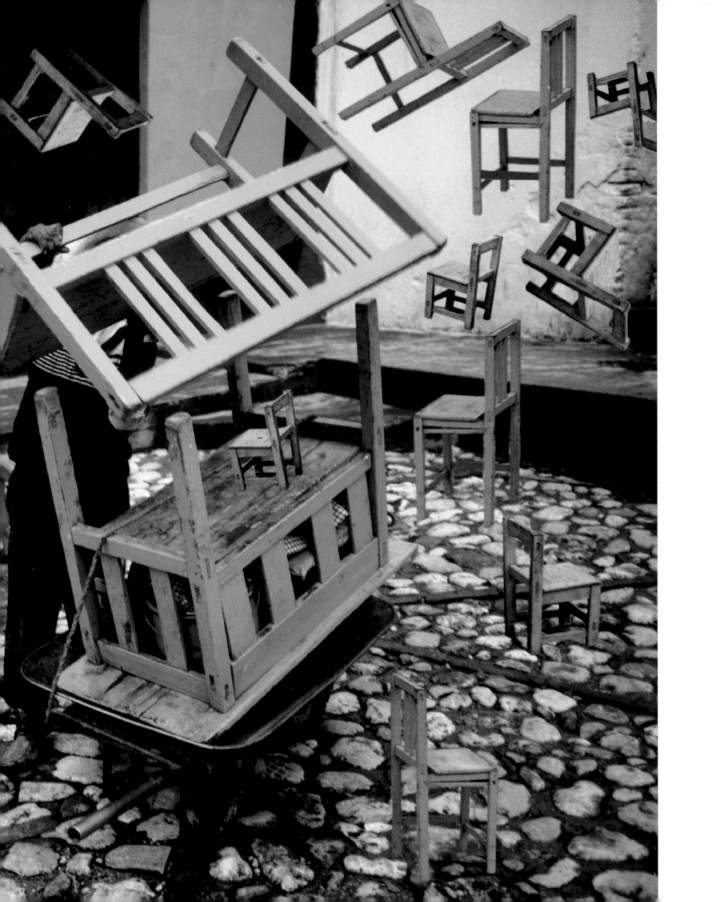

Happily—and overcoming its predictable fate—your letter arrived in El Limbo, posing some truly radical questions in my life. First I had to run and find an expert who could explain to me the digital disk and especially that stuff about the digital revolution. I went into a panic when I imagined a troop of digital soldiers ambushing "my" Limbo.

Anyway, your letter arrived like a message from the gods, with perfect timing. It has only been a few days since the technology of telephones has been installed in our neighborhood. At once I entered a state of euphoria in unison with the rest of the neighbors. Everyone spoke about and raised their glasses to the new life that would commence. Even Doña Elvira, from the grocery store, overcame her shyness, saying that it was like receiving a new member of the family. It was then that I grew pale. My God! My life would never be the same. Will I be sufficiently dynamic, efficient and practical to keep up with these new generations that shorten both time and distance at such a dizzying pace? And what strange power will I possess, having access to so much information by merely pressing some buttons and thereby coming into contact with the whole world?

ROWENA MORALES, ARTIST, MEXICO

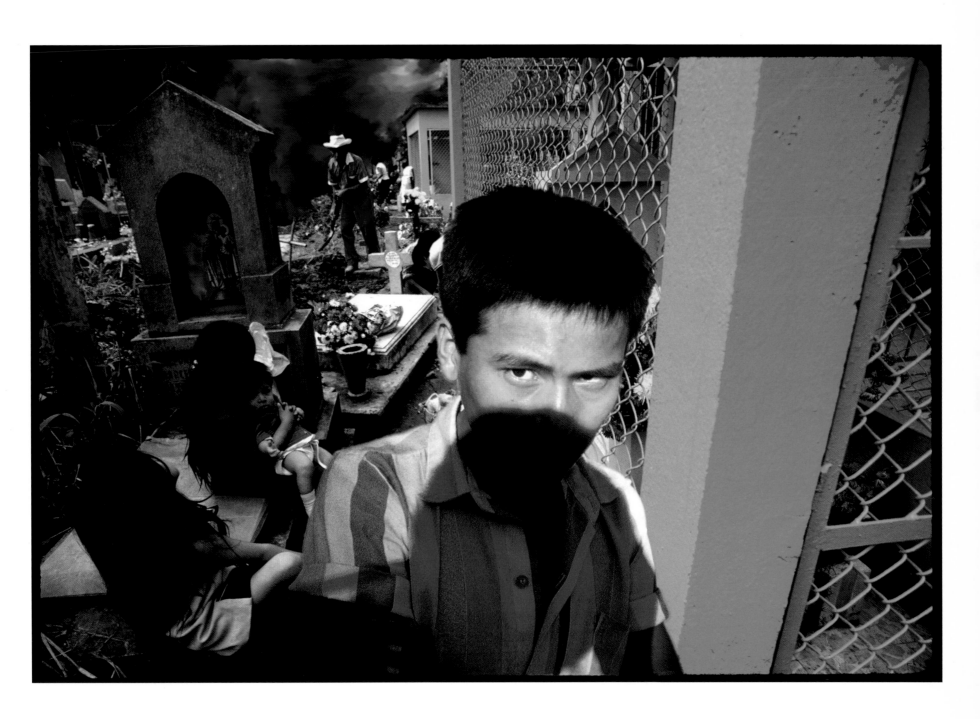

DAY OF THE DEAD, PAPANTLA, VERACRUZ, 1989/91

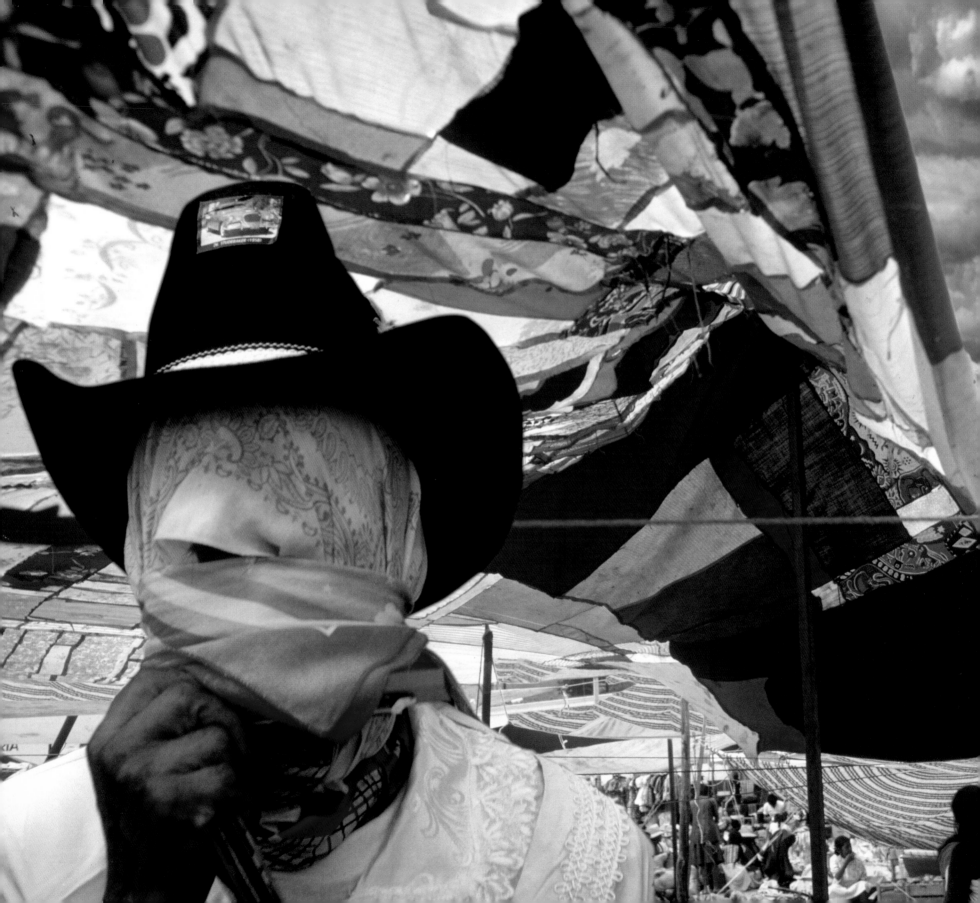

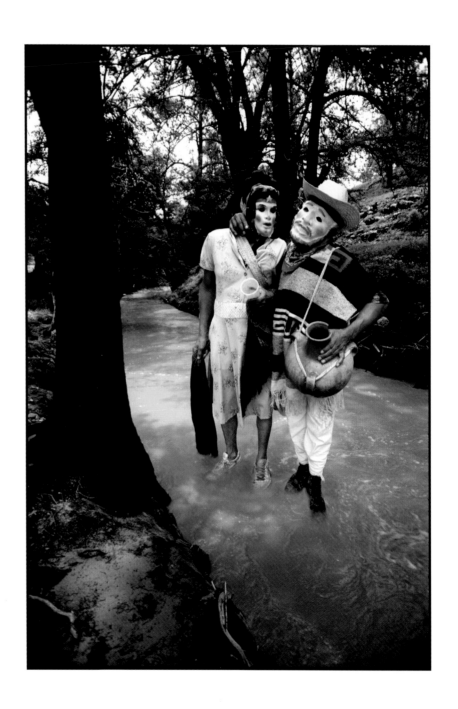

▲ MOSES AND WONDER WOMAN, TEPOSCOLULA, OAXACA, 1991/93
◄ SCARVES IN THE MARKET, TLAXIACO, OAXACA, 1991/93

89

I think that the concept of reality has always been subjective. Since the Stone Age, man has represented his reality in this way. A landscape, an animal, a person— these have always been transformed by the artist in order to attain a more profound impression, one of essence.

CARLOS JURADO, ARTIST, MEXICO

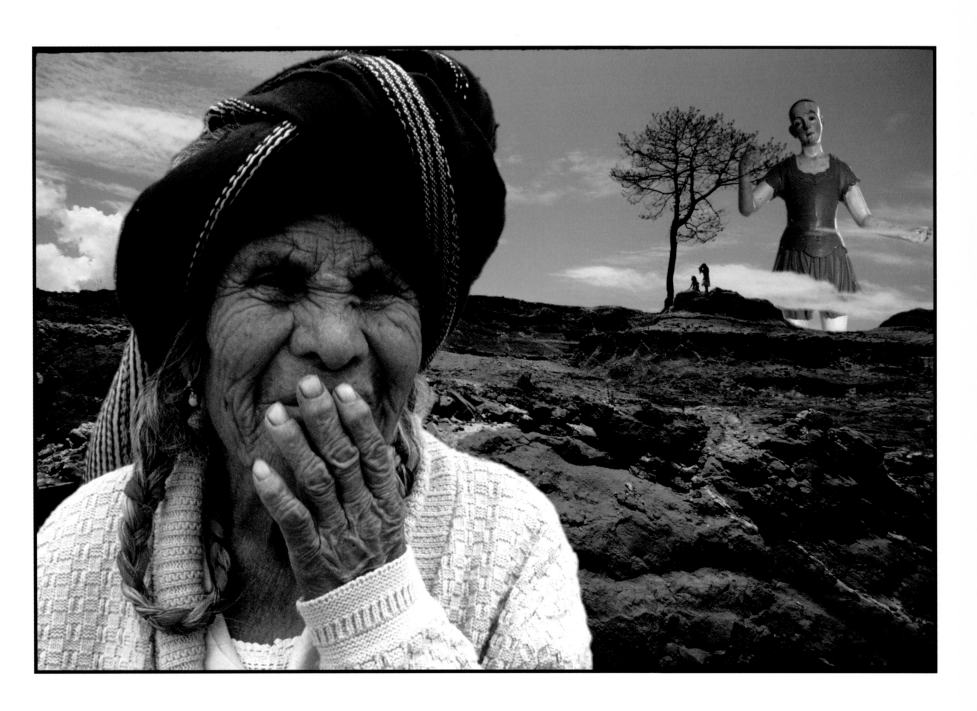

THE ARRIVAL OF WHITE MAN, MAGDELENA PEÑAZCO, OAXACA, 1991/92

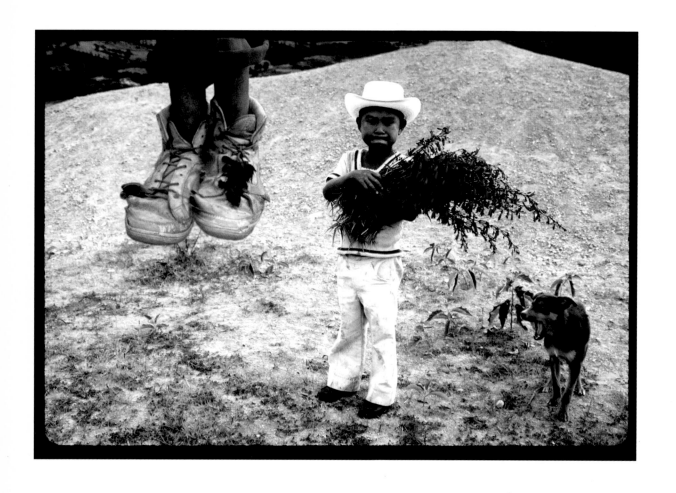

REMEMBERING MARCO ANTONIO CRUZ, TILANTONGO, OAXACA 1991/93 ▲
BASKETBALL COURT, SAN PABLITO, PUEBLA, 1984/93 ▶

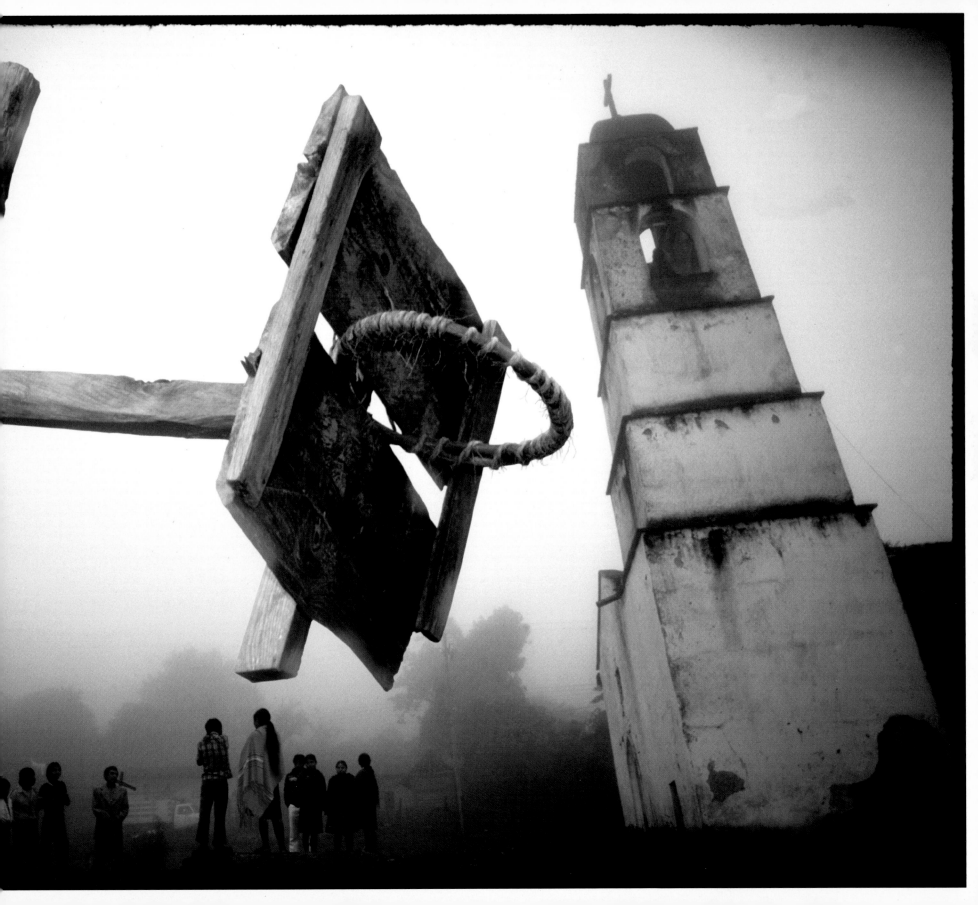

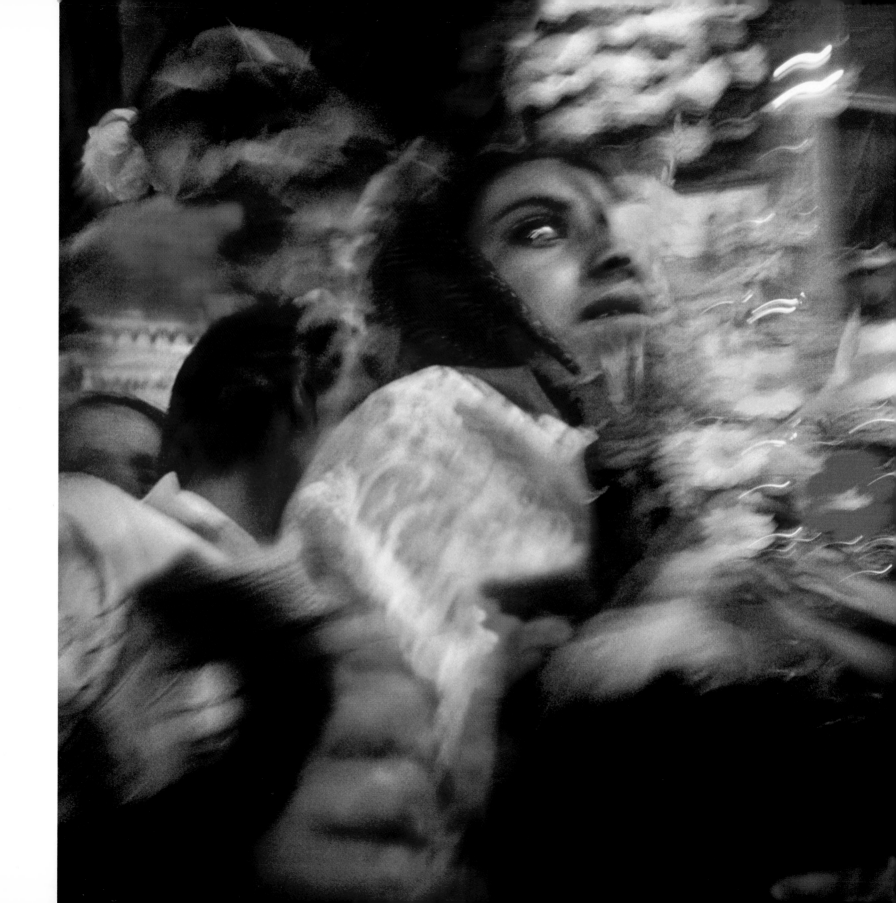

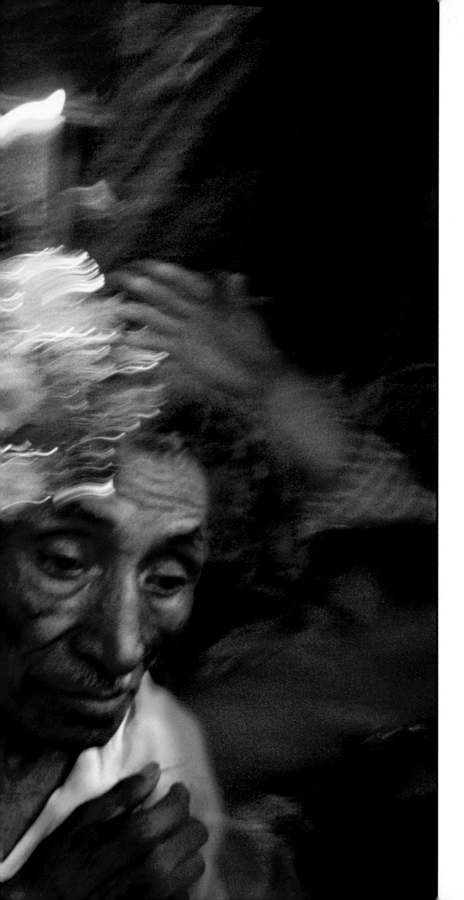

Manipulating photographs will
open our eyes and make everyone
look more critically towards all
flow of information.

KENT KLICH,
PHOTOGRAPHER, SWEDEN

BLIND AT MASS, TEOTITLAN DEL VALLE, OAXACA, 1991/93

I think that although it is necessary, it is pointless to discuss the pertinence of digital photography. My grandmother always resisted cooking beans in a pressure cooker. She claimed that such inventions would put an end to Mexican food. Now nobody would dispute that!

FRANCISCO MATA, PHOTOGRAPHER, MEXICO

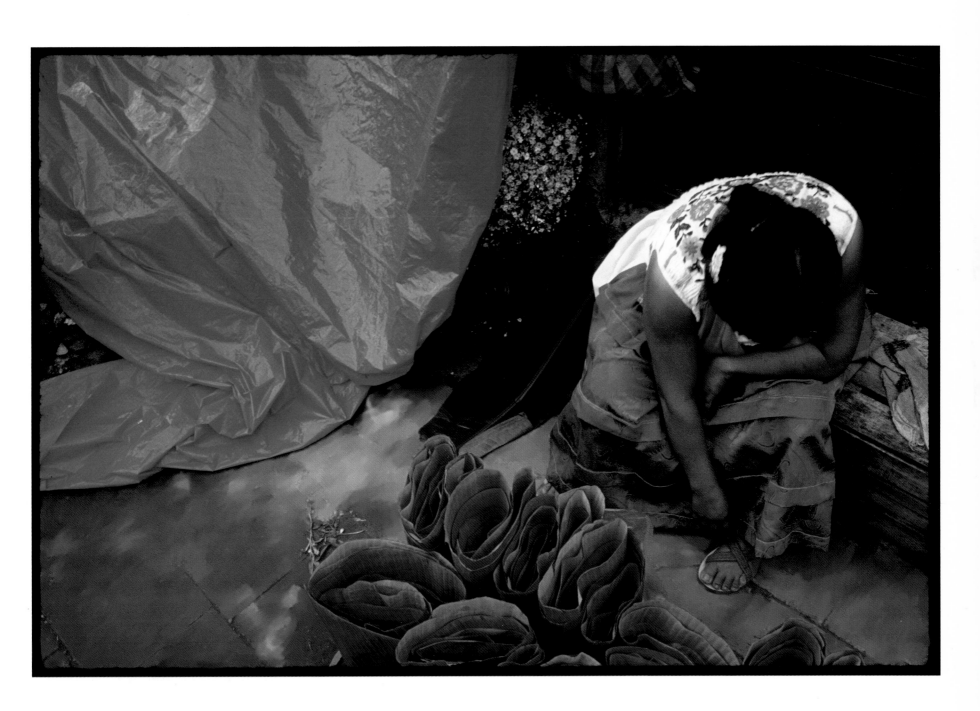

AZUL, PAPANTLA/VERACRUZ, 1989/92

It may be that digital imagery will liberate photography and reality from being questions of representation by sufficiently distorting the truth of both. Art, it seems, thrives wherever and whenever it is set free of expectations.

JAMES ENYEART, DIRECTOR,
GEORGE EASTMAN HOUSE, UNITED STATES

THE CASE OF THE MISSING PAINTING FROM THE ALTARPIECE,
YANHUITLAN, OAXACA, 1991/93

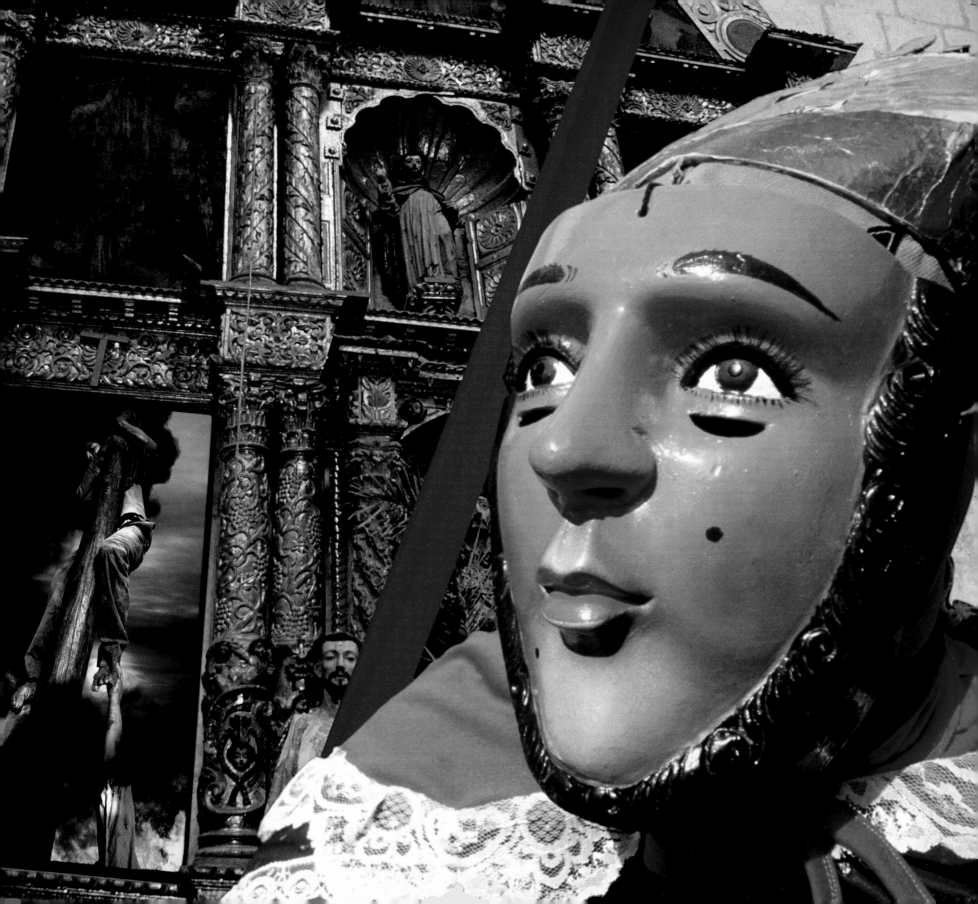

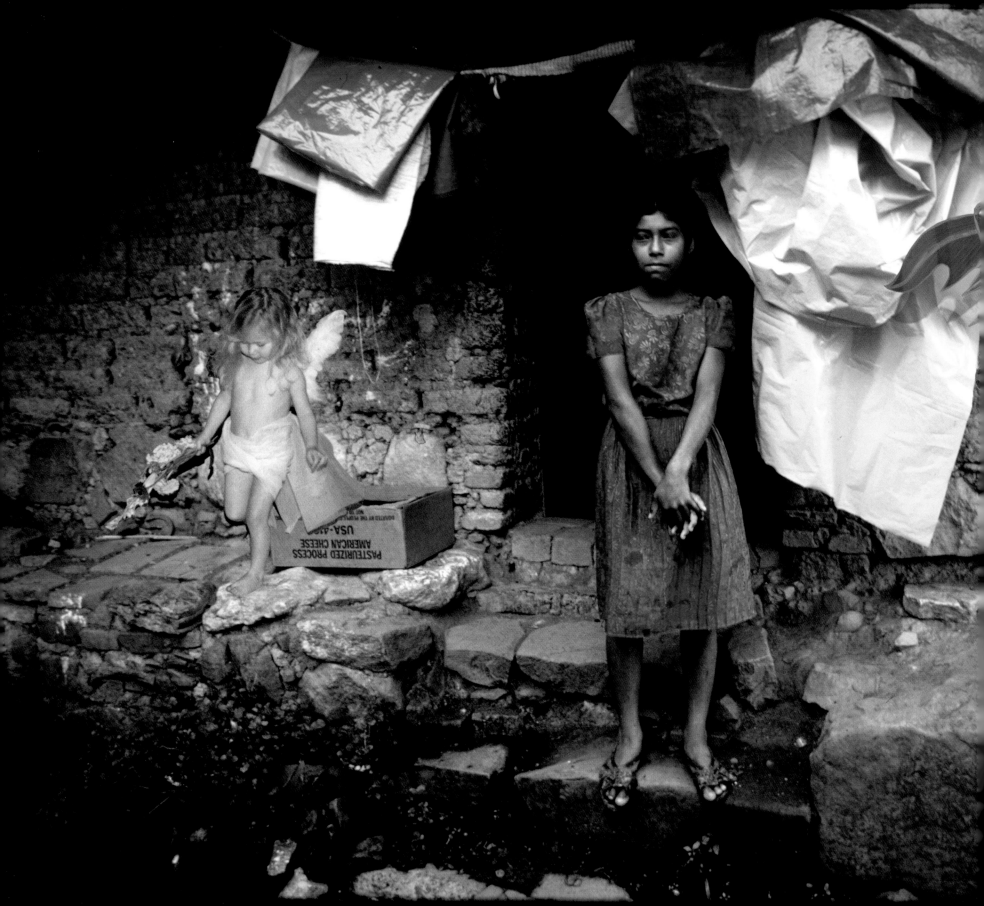

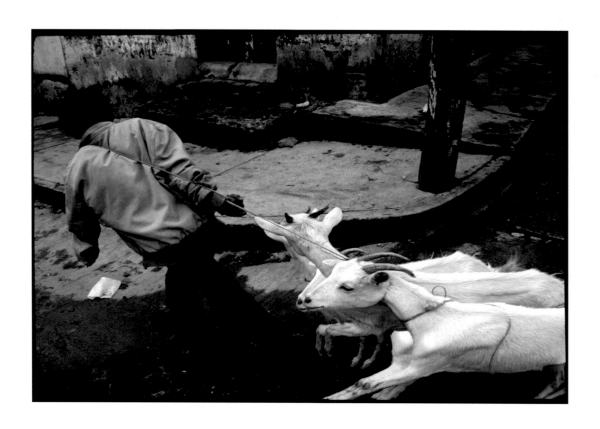

▲ MR. ESCHER'S GOATS, TLAXIACO, OAXACA, 1991
◄ THE ANGELS, SANTIAGO NU YOO, OAXACA, 1991/93

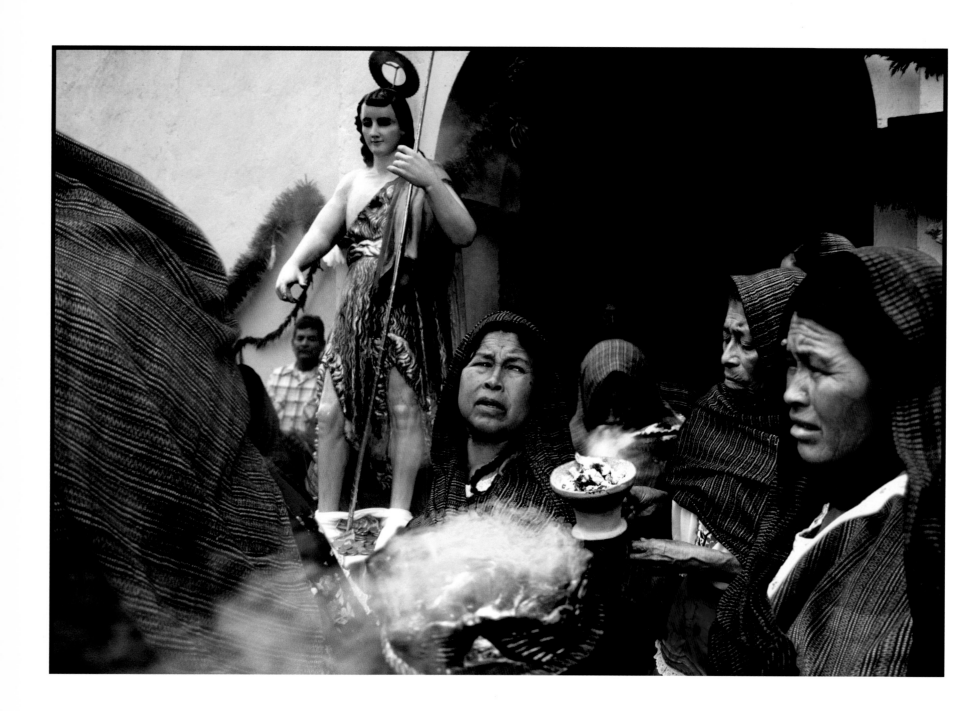

PROCESSION WITH INCENSE, SAN JUAN MIXTEPEC, OAXACA, 1991/93

RELIGIOUS SYNCRETISM, SANTIAGO NU YOO, OAXACA, 1990/93

HOUSEWARMING, MAGDALENA JALTEPEC, OAXACA, 1991/91 ▲
MIXTECOS AT MASS, SANTIAGO NU YOO, OAXACA, 1991/91 ▶

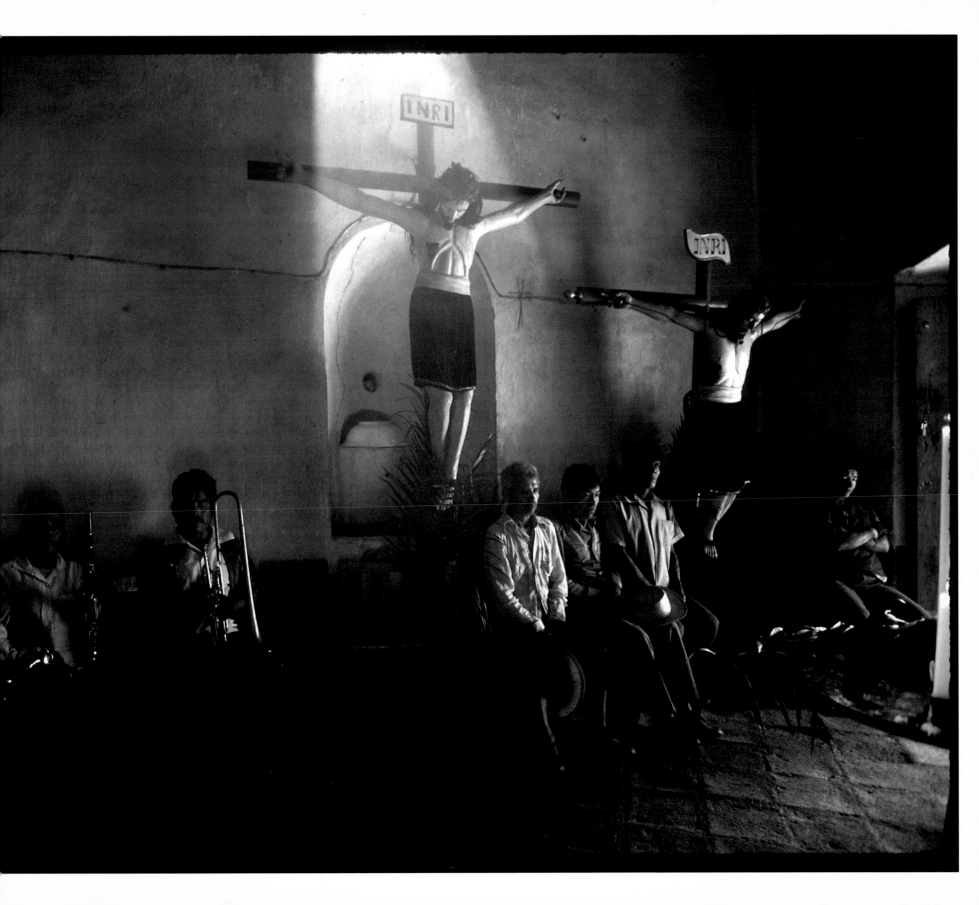

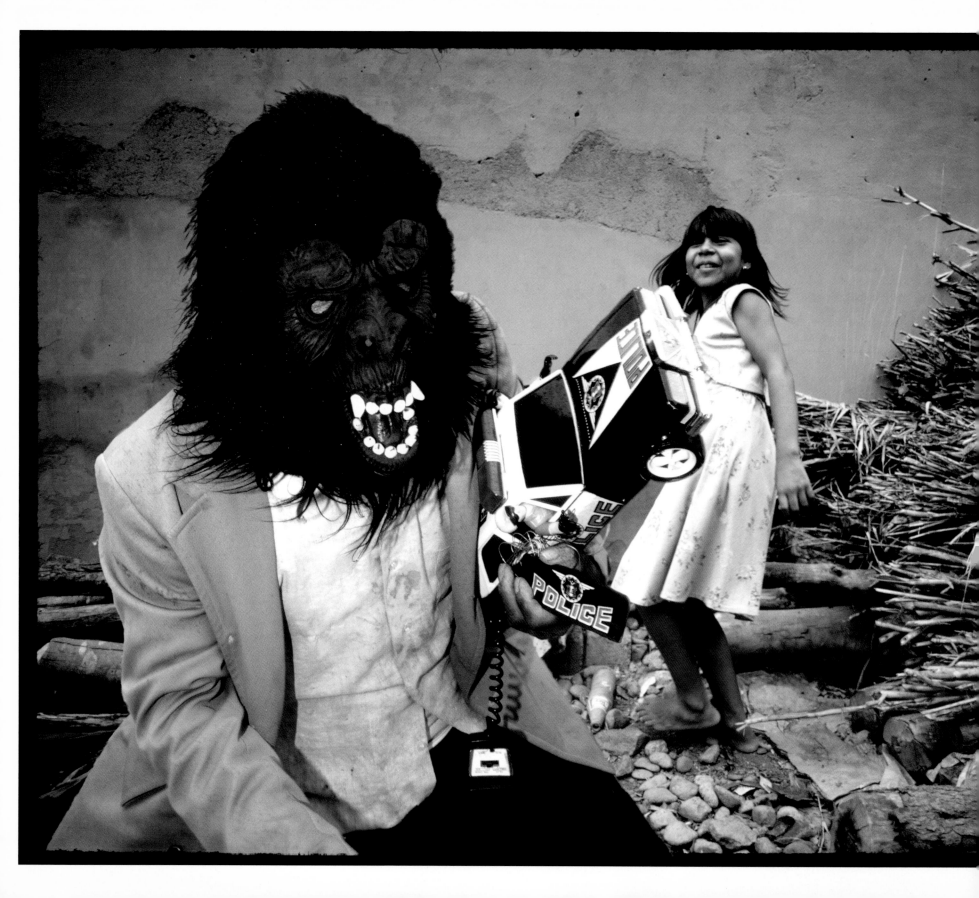

It is fascinating that, after decades of deconstruction—the analysis of imagery as embodiments of power relations—the actual negative and positive, the matrix and the hard copy, are being vaporized away.

MARK HAWORTH-BOOTH, CURATOR
OF PHOTOGRAPHS, VICTORIA
AND ALBERT MUSEUM, ENGLAND

THE SHERIFF, SAN JUAN MIXTEPEC, OAXACA, 1991/93

EXPANDING MEMORY: AN INTERVIEW WITH PEDRO MEYER

■

(conducted between New York and Los Angeles via e-mail during August 1994)

■ MICHAEL SAND: There has been much talk in the popular press and in academic circles about the dangers of the new imaging technology. People seem threatened by the idea that we won't know if photographs have been altered or not. Yet you seem to celebrate the potentials of the new medium.

■ PEDRO MEYER: Through history, people have always felt threatened when faced with new technologies and the changes that they bring about. Indeed, I think we should embrace such changes with caution, but not to the extent that caution hampers our capacity to expand our horizons. I do not arrive at these new technologies driven by any particular interest in them: my encounter comes from the influence derived from the ancient cultures of Mexico, and from a connection to pictographic representation.

The enigmatic civilizations of ancient Mexico have always intrigued and influenced my thinking. I am reminded of the emotion that paralyzed the conquistadors when, from the heights, they looked down for the first time upon the valley, the lake, and the pyramids of Mexico City. Bernal Diaz del Castillo, who was not given to hyperbole, reports this unforgettable moment in simple terms: "Before us we saw many cities and towns—on the water and terra firma. . . . We were wonderstruck, and we said that what lay before us was like the enchantments related in the legend of Amadis. . . . Some of our soldiers said even that what they were seeing was a thing of dreams . . . it is, then, not surprising that I should write of it in this manner, because there is much to ponder in it that I know not how to tell: witnessing things never heard, nor seen, nor even dreamed, such as we were seeing."

And so I, much like those soldiers in 1520, look down upon a valley, only my gaze is directed toward Silicon Valley. Although I see no pyramids, I do see something not unlike them in significance: computers. Electronic edifices which allow us to enter new spaces and witness things "never heard, nor seen, nor even dreamed of." Yet I am reminded that those same Spanish soldiers were about to destroy the entirety of Aztec civilization. This, according to legend, was only possible because the Aztecs believed that their conquerors were gods, riding atop animals (horses) they had never seen before. While the digital revolution is not likely to lead to such confusion, it will certainly take its toll on modern civilization. A lot of upheaval will inevitably ensue, as we go about adopting digital technologies.

■ MS: Can't we learn from the technological turning points of the past?

■ PM: Well, during a recent lecture in San Francisco, Stephen Hawking asked, "Why can't we remember the future?" I see the past as a reference to the future. The issue of memory also drives my curiosity: probably this poor memory of mine serves in part to explain my interest in photography. Instead of remembering everything in detail, I have always made images, and in the process registered the present for future reference. In addition to memory I had my pictures, which, even in their subjective imperfection, helped me to remember. I photographed to remember. The title for my first CD-ROM, *I Photograph to Remember*, was not just a title spun off at random. It was a description of my life as well.

■ MS: And yet the work in *Truths & Fictions* is about the creation of memories, isn't it, since you are fabricating experiences that did not occur?

■ PM: I don't see it that way at all. All my images are about documenting experiences—not fabricating them. The experience in a traditional photographic representation has been limited (though in truth the camera sees more than we do, and therefore is not limited at all) to those elements that the lens was able to capture. To the silver halides or dyes, I now can add my own memory.

For example, the warplanes in the image *Desert Shower* [page 18] respond exactly to my memory; they actually did fly by. I just wasn't able to capture that on film. My limitation, the camera's, who cares? The fact is that what I see on the negative is not what happened in reality: those ominous warplanes did fly

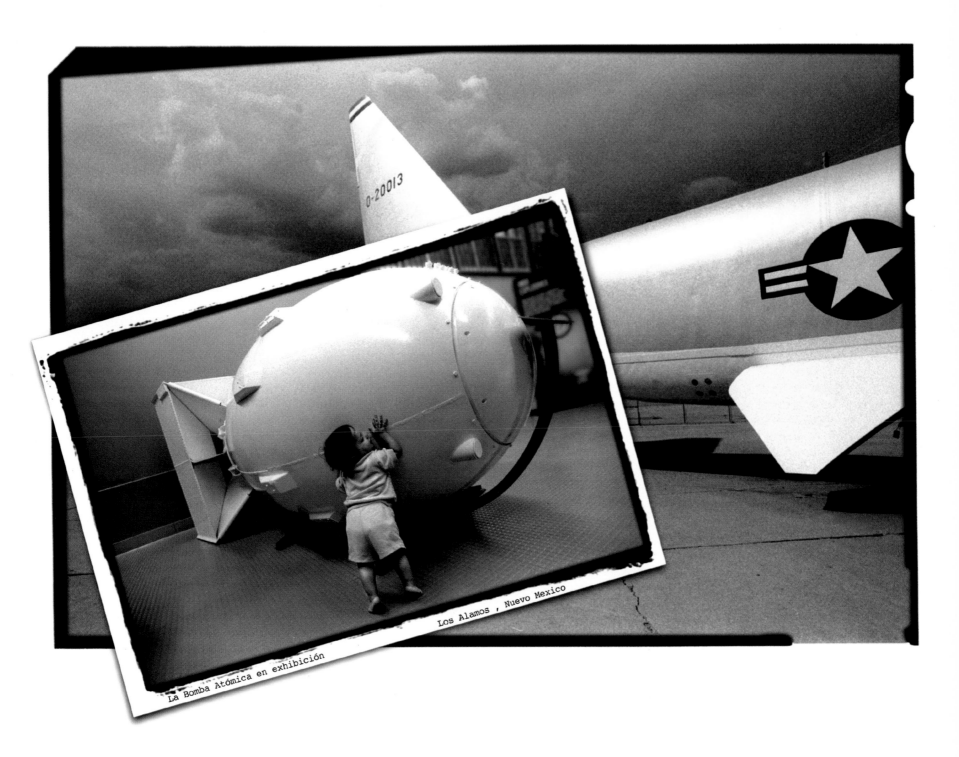

La Bomba Atómica en exhibición

Los Alamos , Nuevo Mexico

THE ATOMIC BOMB ON EXHIBITION, LOS ALAMOS, NEW MEXICO, 1991/95

overhead. Now, with digital technology, I was able to restore the picture to my memory of what actually happened. Did I fabricate an experience in that case?

There is no way that a photographer can produce an image without accessing memory. What makes a photographer choose an angle, a light, a perspective, certain content, is all derived from perceptions that are the defining elements in what makes one person differ from another. All of that is based upon the accumulated bank of references we call "memory."

Memory is a function of our brain that is not all that well understood. But even though I don't quite understand electricity, I do understand what it does for me; it is the same with memory. I am very well aware that all my decisions stem from some memorial reference that leads me to make one choice over another. When I look at a picture it helps me to remember. And now when I create an image or alter parts of it, I am actually restoring to it that which I can recall.

■ MS: The images of the United States in *Truths & Fictions* have the feel of a kind of strange road book. One critic has even described the work as Robert Frank's *The Americans* for the nineties. When you took those pictures, did you have any idea how you would end up altering and using them later on?

■ PM: When I first started out, in 1987, I was on a Guggenheim grant, and I obviously had no idea about anything related to using computers. As it happens, the start of the project coincides with the first personal computers being brought out to market, and the big leaps with computers and pictures date back only to the last four years—in other words, the nineties.

I did have one thing clear: that now-legendary book by Robert Frank broke new ground for the presentation of content and the aesthetics of the photographic image. So when I started on my journey of picturing North America, Frank's book was a reference that no one would let me forget. It is difficult to work on a project that is overshadowed by a legend at the outset. Maybe because of this omnipresent reference, I was clear that whatever I did, I had to make sure not to replicate what had been done so well thirty years earlier.

I soon realized that the country that Frank had pictured was no longer the same one that I was encountering in my travels. I never found those Americans that would fit the description of being *The Americans*; the insinuated homogeneity of the "The" had become a mosaic of different cultures with little or no relationship to what an outsider envisions about the U.S., or to popular perceptions of the country at the time when *The Americans* was being photographed. Yes, there were the whites and the blacks, but none of the other cultures ever made an appearance. The issue simply was ignored.

I also felt the presence of new technologies emerging all over the place, which led me to the conclusion that such technologies would afford me the opportunity to express my ideas regarding photography and the United States, in ways that would differ significantly from what had been done earlier.

Working with computers offered the felicitous combination of responding to many of the issues around photography with which I had been grappling for a long time, as well as opening up new ground with regard to publishing and distributing such work. Much to my surprise, and without planning it specifically, I happened to be in the right place at the right time. This allowed me to address multiple issues in parallel form, both with regard to photographic theories of representation and in connection with many of the social issues represented throughout my work.

■ MS: Can you give some examples of this parallel vision?

■ PM: When I came to photograph in the United States, I was ready to embark on my journey embracing two opposite realities. On the one hand, I was willing to discover and learn what this country was all about, and on the other, I brought with me all kinds of cultural references, which in turn would influence what I was about to see. In other words, I arrived with several preconceptions as well as the willingness to contest them.

One such cultural encounter had to do with modesty, and how the people in the U.S. deal with this issue. I found the U.S. a much more open and free-wheeling society than my own, unanchored from any heritage that would encour-

age such values. In the world I grew up in, the perception of what constitutes "ridiculous" behavior is altogether different from that in the United States. People in North America whom I perceived as acting, behaving, or dressing in outlandish ways apparently had no such perception of themselves. A sense of modesty is almost a negative attribute within American culture. I ascribe our differences to the Indian heritage, which, as Octavio Paz writes: "is present in every Mexican even if that presence is almost always unconscious, and takes the form of ingenious legends and superstitions. It is not a kind of knowledge but an experience. The presence of the Indian means that one of the facets of Mexican culture is not occidental."

This dialogue with modesty is present in the image *Contestant #3* [page 63]. The idea of a beauty contest was obviously not something very noteworthy. However, in the small, rural town of Cave City, Kentucky, I found that the concept of beauty took on a very different meaning from what I would normally associate with such a competition. The presence and absolute dignity of contestant #3, who was noticeably overweight, struck me as quite fascinating. I couldn't imagine a similar scene in an equivalent small town back in Mexico.

None of the other pictures I took of contestant #3 revealed her dignity as well as when she was standing there in the doorway, with her escort ready to bring her to the podium. However, the image was misleading on two fronts: those who saw the initial unaltered version could not understand what was going on, and the reference to how she looked in contrast to the other contestants—an important part of the meaning of the image—was not present in the original. When I brought contestant #1 into the picture, the image became more self-sufficient, and its meaning was extended.

This begs the question, "Why didn't I photograph that to begin with?" The answer is quite simple: the layout of the space where the contest was held offered many possibilities, but not this particular one. Under traditional circumstances, I would have given up on representing this moment. As a matter of fact, I did not consider altering the image at the time I took it; this only occurred to me upon inspection of the contact sheet, when I observed that all the images from that initial moment fell short of the visual statement I wanted to make. In every

one, content and geometry had failed to come together, to borrow Max Kozloff's phrase. This specific "decisive moment" wasn't to be found, it had to be created, much as photographers have done all along when they patiently wait for their subject to perform as anticipated. The only difference is that they bide their time before the shutter clicks, and I do it afterwards.

■ MS: Do you think you will ever return to straight documentary photography?

■ PM: The question implies that I have left the straight documentary tradition, doesn't it? So let's first address the question of what can be considered "straight." I think that such a notion is, after all, only a convention determined by certain customs, technological limitations, and traditions. An ancient Egyptian or a Mixtec would probably not recognize photographs as constituting a "straight documentary" representation. My work will also be seen as "straight" by coming generations. We are in for some serious rethinking of photographic theories of representation, especially when it concerns the documentary tradition.

■ MS: You have referred to your early work as "B.C," meaning "before computers." Do you see the computer as a kind of savior?

■ PM: Well, today being "A.C.," I no longer have to stand for twelve hours at a time inevitably exposed to all those chemicals in the darkroom. As I grow older and my vision increasingly fails me, I can still make up with experience what I lack in agility out in the field. When geometry and content miss their original appointment, I can try to make up for such a lost encounter. I can, like a gold miner, go back to all my old archives and find countless new veins and find new uses for my previous work. I can publish upon demand. With ease I can erase scratches which would have defied the artistry of the most sophisticated retouchers. For these and a thousand other reasons too many to enumerate, the computer is, if not a savior, at least an excellent tool to mitigate our limitations and to expand our expressive potential.

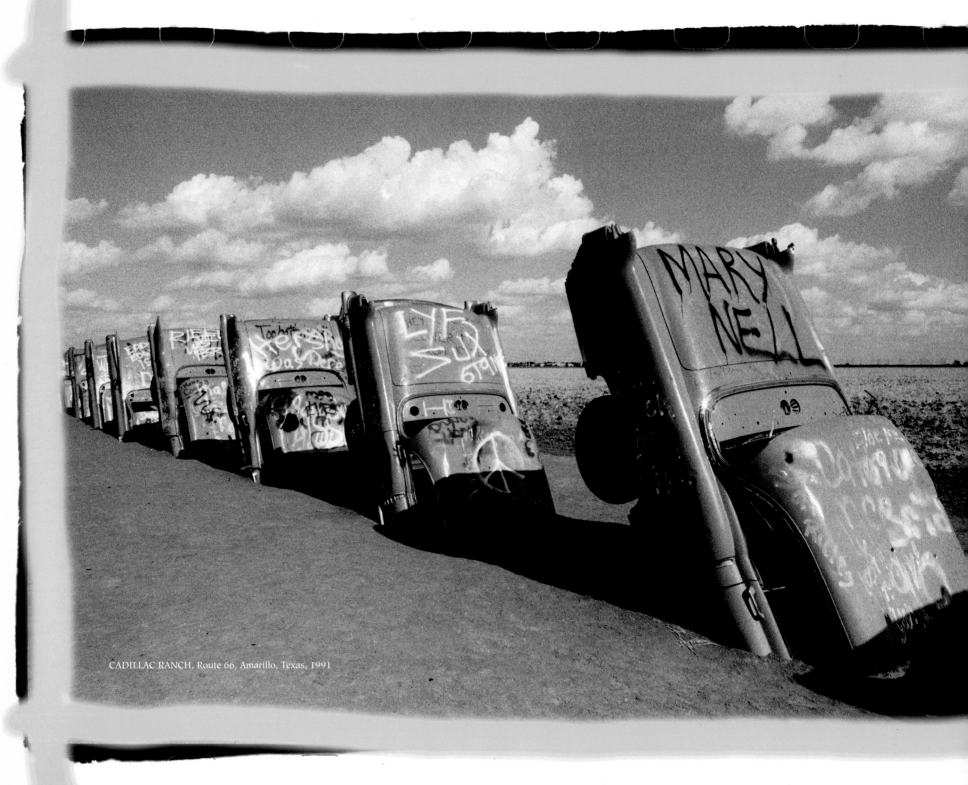

CADILLAC RANCH, Route 66, Amarillo, Texas, 1991

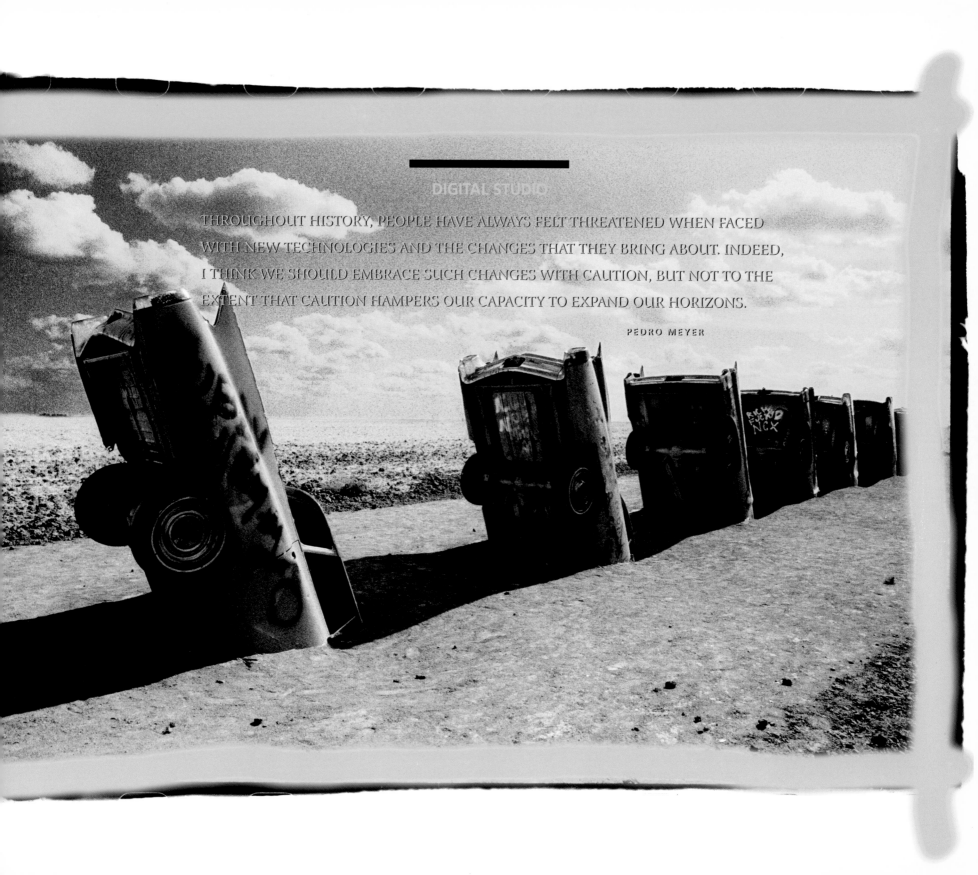

DIGITAL STUDIO

THROUGHOUT HISTORY, PEOPLE HAVE ALWAYS FELT THREATENED WHEN FACED WITH NEW TECHNOLOGIES AND THE CHANGES THAT THEY BRING ABOUT. INDEED, I THINK WE SHOULD EMBRACE SUCH CHANGES WITH CAUTION, BUT NOT TO THE EXTENT THAT CAUTION HAMPERS OUR CAPACITY TO EXPAND OUR HORIZONS.

PEDRO MEYER

Walking Billboard, New York City, 1987/93

■

(Changing background to put foreground in a new context)

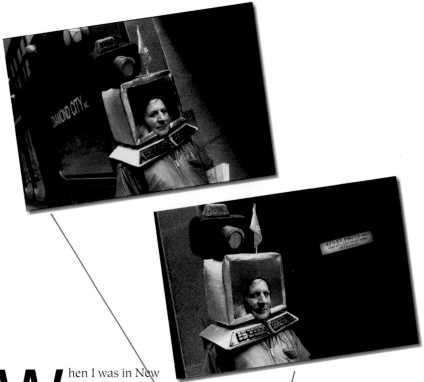

When I was in New York I had the opportunity to speak with this man, who was standing in front of a camera store. He was a Russian immigrant who had just arrived. He barely spoke English, so we chatted as best we could. I didn't know what he was doing in the United States, except that he had a job as a walking billboard.

I took a few portraits of him; one where the background is quite interesting but he is less so, and another where I feel he looks better, but the background is not as attractive. Through digital means, I was able to drop him into a photograph I had taken earlier in Central Park, one which includes such iconic elements

as a game of baseball and the skyscrapers of New York. I had to find an image where I could position him in such a way that the light made sense, the references to the rest of the image worked, and the proportions were right. In the end, I was able to create an environmental context that made sense for the image.

This process allows us to do things that we have not been able to do in the past with the degree of ease with which they can be accomplished today. What happens, I think, is that the image

becomes much more succinct, much more compact, and you are able to convey your message, your intentions, with much greater clarity. In the first portrait, reality constrained me. In the final one, I was able to make my statement much more eloquently.

Emotional Crisis, Texas Highway, 1990/93

■

(Increasing the levels of content)

I was driving down the highway in Texas, when all of a sudden I found myself looking up at a billboard that read "Emotional Crisis." I had never seen anything like it. Placing an advertisement for Emotional Crisis on the highway made the concept into a *commodity*—an amazing phenomenon that is perhaps unique to the United States.

I stopped my car and I took a picture. I had no intention to wait a week or ten days or whatever time it would take for something to happen—a cow to come by, say—so I could achieve a "decisive moment" of the kind so often sought by photographers, so I just took the picture as a record of the sign.

Sometime later, I was driving along on another highway, and I saw this train rolling by. Beautiful. Fascinating. The symmetry of the lines of the railroad and the lines in the highway and the lines of the telephone poles—all these things came together with such perfection. And although I knew it had been done a thousand times before, I decided to take that picture just for myself.

Sitting in front of the computer, I thought, "I would love to be able to use that image, but I would have to modify it in such a way that it would be different and interesting, as well as meaningful." I remembered that I had the billboard, and decided to bring it into this landscape. But it still wasn't quite right. All of a sudden it occurred to me to place that little wiggle in the middle of the highway—sort of a nod, a wink of the eye. It allowed me to combine the landscape, the billboard, and a bit of humor.

In this image I was trying to juxtapose the billboard, which deals with the commodification of emotional crisis, with a feeling of solitude here in the United States, a feeling of emptiness, of life passing you by, while still trying to maintain some humor.

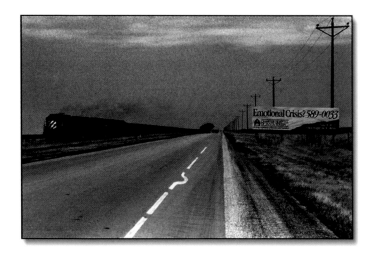

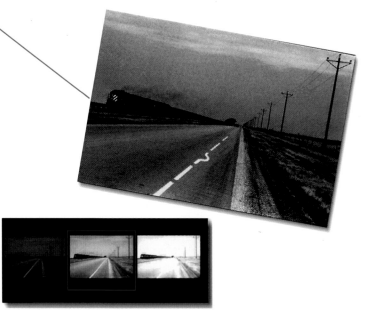

The Storyteller, Magdalena Jaltepec, Oaxaca, 1991/92

■

(The computer screen as stage, the photographer as director)

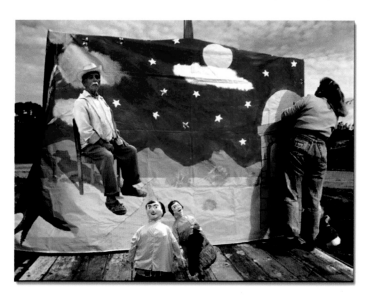

This image started out with the backdrop, which was mounted on a platform on the back of a bus. I thought that this was a lovely beginning for a children's story, or a play. Many times, when I am sitting in front of the computer, I feel like I am the director in a theater: in front of me is a stage, and I am going to call in different actors and set different elements of the stage. This is exactly how I felt with this image. Here was a stage, and this was the backdrop.

Someone once asked me whether I consider myself more a painter than a photographer when I sit down at the computer. But I find a closer equivalence with the theater than with painting. The screen is a stage—it's not so much a canvas as a stage.

Not very far from where I took the picture, I found this lovely man. He was sitting by the highway in his chair, and he was like a grandfather telling stories to the world. I thought, "I'm going to place him in the backdrop to tell us a story about these huge three-dimensional figures with little people inside." Since these were part of his story, I decided to make them small and put them on the stage in front of him.

The first time I tried it I couldn't figure out how the shadow of the man sitting, or hanging, or being, in that backdrop should work. I spent nearly two days figuring out where the shadow would go. I have learned more about lighting working with the computer than I ever did working with a camera. When you work with the camera, if you're working outside in the world, you use whatever light there is. But when you're working with these images inside the computer, you actually control light and shadow—more so than in a studio.

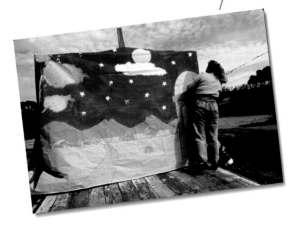

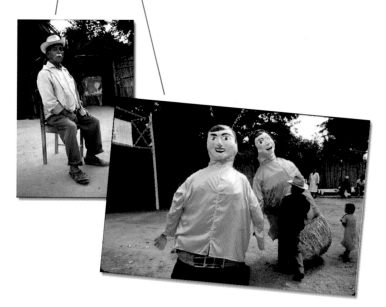

The Strolling Saint, Nochistlan, Oaxaca, 1991/92

■

(The representation of dreams)

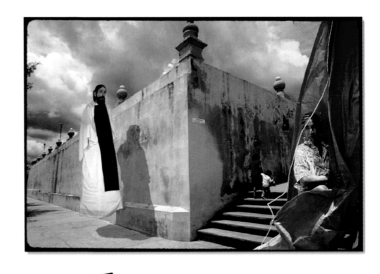

One of the interesting things that I have discovered, in going back to look at the images in their first stages, is how empty they look compared to the finished image. The original images from which I started look totally abandoned and empty.

I began with this picture because I loved the blueness of everything. And there is the tenderness of this woman walking with her child up the stairs. But from the beginning, I saw the image as a setting where I could introduce a number of interesting ideas and events.

I had taken a picture of this woman enveloped in blue canvas at the house of a friend. When I brought her into this image, it was suddenly as if she were pulling aside a curtain to reveal the stage setting of a small town in Mexico. Often, these small towns have stories about strolling saints, and I decided that this was the appropriate place to re-enact that vision. After a few tests with other figures, I remembered how impressed I was with this particular saint, whom I had photographed in the courtyard of a nearby church. He seemed very mysterious to me, this large saint

in a rather small niche. So I decided to take him for a stroll. And since he didn't have any feet, I thought he should be levitating, just floating through the air comfortably, accompanied by his shadow.

In the final picture, I also took out some of the poles: the wooden pole in back of the blue curtain, and the one in the middle of the picture. Cleaning up all these little details made it somehow more ethereal. With digital photography, one can make images that are representations of dreams, where the imagination can flow, or levitate, much like the saint.

The Temptation of the Angel, 1991/91

■

(Photographic rendering of the intangible)

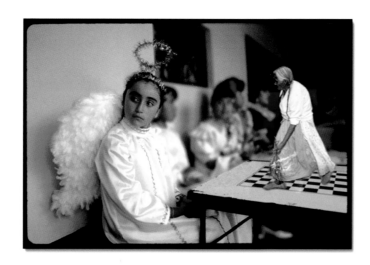

This is an image that is much less straight-forward than it appears. And it uses digital technology to do things in ways that I find quite delightful, and which couldn't be done any other way. Looking at the first image, you will see that I had to throw *out of focus* all of the elements except the angel. Now, to be able to put portions of an image out of focus after having taken it is quite remarkable. Here I blurred the elements underneath and above the table, being careful that it remained logical from an optical point of view; then I deleted all the Pepsi signs, which I thought were completely out of place.

I had pictures of this woman who was showing me how she prepares the fire to light up the *temescal*, which is a traditional Mexican steam bath. Here she was with these branches on fire, and I thought that it would be like bringing temptation to the angel to have her walking across this chessboard. She had to be small, spatially and metaphorically. The angel, looking off to the left, is totally distracted, unaware of this threatening figure approaching her with burning branches.

Biblical Times, New York City, 1987/93

■

(Stretching conventional boundaries of journalistic representation)

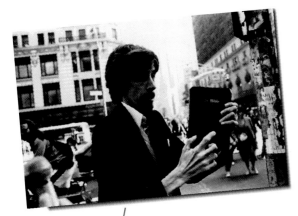

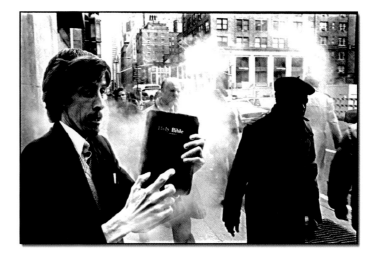

I was walking around New York, trying to capture some street images, as I often do. And I found this man with hands like an El Greco figure. People were walking by—nobody was paying much attention. I photographed him from one side, then from the other side, but nothing of significance was coming across the viewfinder.

It was impossible to make the background any better, due to the limitations of space and optics. With a long lens I could have thrown the background out of focus, but I would have lost the sensation of the man, his Bible, and those long hands, as well as all the people walking on the street getting in front of him. Unsatisfied as I was, I nevertheless took the picture with a wide-angle lens from close up. In contact sheets of some other pictures I had taken earlier on that same day and on the same street, I found this image with some steam, which was enveloping the people as they walked through. This led me to bring these two scenes together in order to overcome what had eluded me before—that is, to pull in form and content in such a way that the image became more meaningful.

I was actually able to simulate the steam around his hands and around the Bible digitally, at which point the image—as I see it—took on a totally different dimension. His hands become a strong element and the figure walking past conveyed the sense that nobody was paying attention to this Bible salesman, as was the case. The result is actually a much more powerful image of New York. And, though it stretches the conventional jounalistic boundaries of today, it is truthful to New York.

Mexican Serenade, Yuma, Arizona, 1985/92

■

(The photograph as a political cartoon)

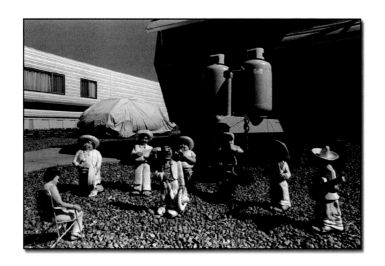

I was in Yuma, Arizona, which is a very interesting place to photograph. It is a small town, and my experiences there were completely new and different. A large portion of the people there live in trailer houses. I used to say that it was the ultimate American dream to live inside of an appliance—not only to have them but to live inside of one. I would stroll around these places, and to my great amazement, they often had these and other little figures of Mexicans displayed outside their homes—which I found quite offensive, actually. We were thus reduced to these ceramic mariachis in a very unpleasant way. And there was nothing much I coud do with that image.

But when I started working with the computer, it dawned on me that I could do something. I could bring "down to size" the people who were reducing the Mexicans by means of this cartoonlike representation. And that's precisely what I did. I brought a person from this community down to the scale of the little mariachi figures, and in the process addressed the issue of racism.

Live Broadcast, San Juan Mixtepec, Oaxaca, 1990/93

■

(Building around the strongest image)

I had this image of a man holding a box, and I found that the way he framed himself—like a television set—was very meaningful. However, only half the frame worked for me, and in the other half there was nothing going on. This happens quite often, that part of an image works, and the rest doesn't. Well, now we are able to expand the potential of such images.

When I combined it with an image of a wall covered with religious icons, the man became an icon in a television set. All these references play off each other. However, I realized that a large portion of the beautiful images hanging on that wall would be left behind, and where the television set was, it would be empty. I moved the icons over to the other part of the wall, and in so doing made it visually

much more complete. I now had the relationship between him, the representations of him, and the frame of the television set. What was missing was what the actual television set was going to be showing. By bringing the Devil into the TV (many refer to the television as "bringing the Devil into one's home"), I drew a further connection between the man, the television, and the icons.

Freeing Film, New York City, 1987/93

■

(About freeing film)

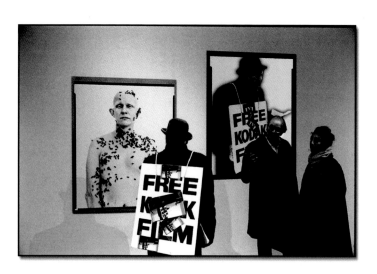

I was in New York, going to an exhibition of Richard Avedon's photographs. On my way over to the exhibition, I was taking pictures in the street, and I came across this man in a homburg hat and a black coat, quite elegant looking, carrying a billboard that said FREE KODAK FILM. I read it in the two ways it could be read: first as an appeal to free or liberate film, and second as a commercial offer of film being given away.

I took that picture many years ago. Later, when I discovered what the computer allows one to do, I started to explore such possibilities. For example, I took the man from the picture in the street and made an image "à la Avedon," with his traditional

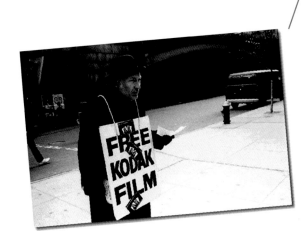

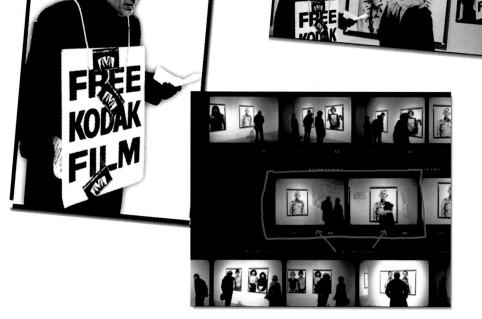

white background and the black frame from the negative carrier. Then I went back to the original contact sheet to see where I could possibly place—within the exhibition—such a picture "à la Avedon," derived digitally from my own street photograph. This image I then placed on the wall and I "invited" the man with the homburg hat to visit his picture at the exhibition. Once I did that, I realized all of a

sudden that something quite unusual about perception had occurred. The man standing there with his billboard ceased to be just a photograph; he suddenly became a direct representation of himself as a person—although I was still looking at a photograph!

As I was not happy with my results, the next day I started all over. I went back to my contact sheet and looked for another background. Again I hung my picture on the wall, this time in back of the two

people standing there chatting. And once again I brought my guest along to the exhibition, much as I did earlier, however it just did not feel right. So I went back to my contact sheets to find a different angle on the man with the billboard. As you can see, I exchanged the front view of the man for a rear view. Suddenly he took on a different presence in the way he was standing there, looking at the images and participating in the exhibition (final image). The visitors to the

gallery now appeared to be talking about him, and a visual dialogue was generated. I was able to add the shadow of the man standing there, and with "digital tape" I pinned the street picture (to serve as a reference) over the billboard, replacing the little pictures that he was displaying.

The image of the man standing there, like a Magritte figure, is in the process of freeing film from its traditional moorings of representation.

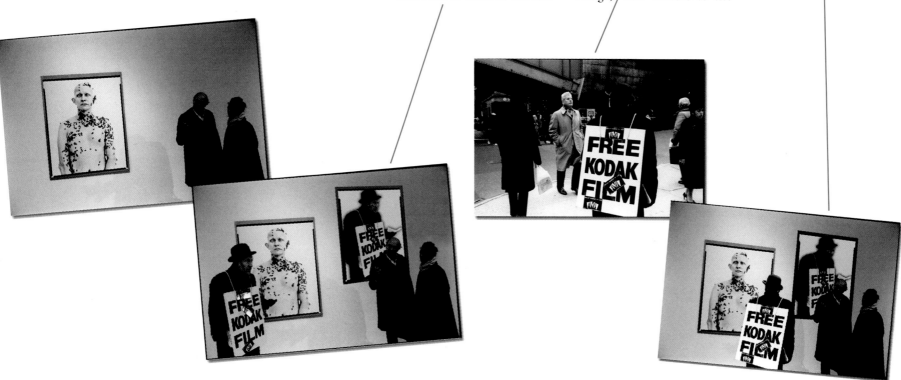

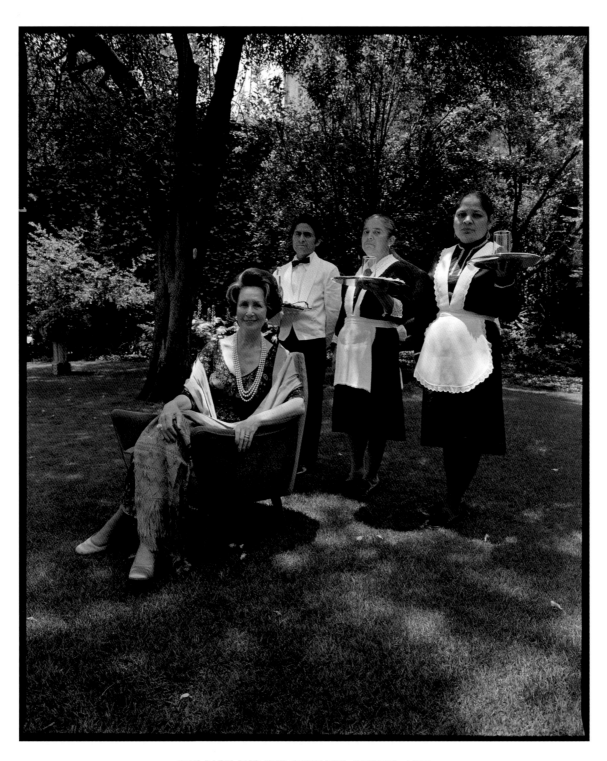

THE LADY AND HER SERVANTS, MEXICO, 1979

CHRONOLOGY

1935
Born in Madrid, on October 6.

1937
Emigrates to Mexico along with his parents. In 1942, Meyer becomes a Mexican citizen.

1948
Receives a second-hand twin-lens camera for his birthday. Teaches himself photography.

1953
Receives bachelor's degree from Babson College in Wellesley, Massachusetts.

1955
After college, Meyer briefly joins his father's business as a supervisor in the production of plastics, a new technology of its time.

Joins the Club Fotográfico de México, the only photographic organization in Mexico City at the time, but finds that its emphasis is on equipment rather than issues of substance.

1959
With twelve workers, Meyer sets up a small shop to man-ufacture decorative lamps for the home.

1963–67
Together with a group of dissident photographers from the Club Fotográfico, Meyer becomes the founder of the Grupo Arte Fotográfico; he organizes collective projects and sets up discussions that deal with photography as a means of expression. The group has numerous exhibitions in galleries all over the country.

Photographs the Chapultepec Park in Mexico City and produces the first audiovisual program made in Mexico, which is widely shown. The Leitz camera company presents Meyer's work at the International Photographic Fair in New York City in 1966 as a successful example of work produced with new technologies.

1968
Meyer's lamp shop, having grown to a factory of two hundred workers, burns to the ground because of an acci-dental explosion in one of the gas kilns; several workers and the production manager die in the accident. The experi-ence of rebuilding and taking care of the needs of his work-ers leaves an everlasting im-pression on Meyer.

Photographs in the streets in Mexico City, documenting the events that lead up to the social uprising and the mas-sacre just before the 1968 Olympics.

1972
Travels to Israel and makes a photographic essay on the aftermath of the war and the arrival of new immigrants from the Soviet Union.

1973
A retrospective of his work from the past twenty years is presented at the Instituto Mexicano-Norteamericano de Relaciones Culturales de la Ciudad de México. Carlos Monsiváis writes the intro-duction to the catalog.

1974
After having rebuilt and enlarged his factory to a work force of five hundred strong—producing wooden furniture, ceramic dinnerware and pic-ture frames—Meyer leaves the business to work full-time as a professional photogra-pher.

1975
Visits New York, Paris, Milan, and Arles to learn more about what is going on in the field of photography; meets Cor-nell Capa in New York, Lan-franco Colombo in Milan, Lucien Clergue in Arles. Dis-covers that Latin American photography and photogra-phers are virtually unknown in these cultural centers.

1976
Starts creating a network that will lead to the first of sever-al colloquia on Latin Ameri-can photography.

The Addison Gallery of Amer-ican Art in Andover, Mas-sachusetts, and the Boston Museum of Fine Arts pur-chase images, Meyer's first collections outside of Mexco.

1977
Creates the Consejo Mexi-cano de Fotografía in order to organize the First Colloquium on Latin American Photogra-phy. Named the first presi-dent of the organization.

With a few colleagues, Meyer negotiates with the authori-ties at the Instituto Nacional de Bellas Artes in Mexico to create a photographic bien-nial, distinct from the other arts. The jury of the Biennial of Graphic Arts declares itself incompetent to evaluate pho-tography and rejects the plan to give out awards for pho-tographs submitted to them.

1978
Travels extensively in Nic-aragua photographing and interviewing the people, including then-dictator Anas-tasio Somoza. Makes contact with the Sandinista guerrilla forces and becomes the first photographer to be allowed access to cover the Sandin-ista training camps.

Presides over the jury of the Primera Muestra de Fotografía Latinoamericana, "Hecho en Latinoamérica," presented during the First Col-loquium on Latin American Photography at the Museo de Arte Moderno in Mexico City.

1980
Named president of the organizing committee for the Second Colloquium on Latin American Photography.

Re-elected president of the Consejo Mexicano de Fotografía; opens the Casa de la Fotografía, which is to become the center for photographic activities in Mexico City.

Curates the traveling exhibition "Siete Portafolios Mexicanos," which opens at the Centro Cultural de México in Paris, France, and edits the accompanying catalog.

Receives award during the Primera Bienal de Fotografía de México. His work is bought by the Instituto Nacional de Bellas Artes for their permanent collection.

1981
Edits the catalog for the Second Colloquium on Latin American Photography, which takes place in Mexico City under the auspices of the Consejo Mexicano de Fotografía and the Instituto Nacional de Bellas Artes.

Curates the exhibition "Diez por Diez," which travels throughout the United States.

1982
Member of the jury for the Primer Encuentro Nacional de Fotografía Contemporanea de Ecuador, in Quito, Ecuador.

Invited to be an advisor to the W. Eugene Smith Foundation, New York City.

1983
Acquires his first personal computer.

Photo essay produced with Graciela Iturbide for the Premio de Fotografía Contemporanea Latinoamericana y del Caribe 1983: "Juchitan: Retrato de un Pueblo," Premio Casa de las Americas, Havana, Cuba.

1984
Member of the organizing committee for the Third Colloquium on Latin American Photography, to be held in Havana, Cuba.

Invited to be on the advisory committee to nominate the annual awards given by the International Center of Photography, New York.

Receives an award at the III Bienal de Fotografía de México. The Instituto Nacional de Bellas Artes purchases Meyer's work for their permanent collection.

1985
The Arizona Commission on the Arts and Arizona Western College offer Meyer a two-month artist-in-residence grant to photograph in and around Yuma, Arizona.

Receives the Premio Internazionale di Cultura Città di Anghiari from the Comune di Anghiari, Italy, who publish *Tiempos de América*, a book containing eighty-six of his images.

Helps initiate the "Rio de Luz" project, a collection of photographic books by Latin American photographers published by the Fondo de Cultura Económica, Mexico City.

ASH WEDNESDAY, 1975

Starts "El Taller de los Lunes," a three-year workshop for young photographers at the Consejo Mexicano de Fotografía, Mexico City.

1986
Travels to Israel as a guest of the First Israeli Bienal of Photography at the kibbutz Ein Harod; leads workshop with Joan Fontcuberta, and lectures.

Awarded first prize by the Organización Internacional del Trabajo, in Santiago de Chile. A catalog of his images is published.

Curates an exhibition on Mexican Photography for the New Orleans Museum of Art, New Orleans, Louisiana.

Member of the jury of the first national photography contest organized under the auspices of the Partido Socialista Unificado de México.

1987
Receives a John Simon Guggenheim Fellowship grant to photograph in the United States.

Photographs the lives of Mexican oil workers for a book commissioned by Petroleos Mexicanos, the national oil company.

1988
Member of the W. Eugene Smith Foundation awards jury.

Los Cohetes Duraron todo el Dia (The fireworks lasted all day), his book on the Mexican oil workers, is published.

Teaches at the Friends of Photography workshops in San Francisco, California, with William Klein and Larry Clark.

1989
Presents a lecture, "The Electronic Image and the Future," at the Palacio de Bellas Artes, Mexico City.

Coordinates and develops the exhibition "Mexico as Seen Through Foreign Eyes," curated by Carol Naggar and Fred Ritchin in collaboration with Pilar Perez.

Helps initiate the Mother Jones Foundation for awards in photojournalism.

Travels 15,000 miles throughout the United States working on the Guggenheim project.

1990
Concentrates on learning all the new digital image-making technologies; sets up a studio in Los Angeles, California.

1991
Publishes CD-ROM disk *I Photograph to Remember* with the Voyager Company. Presents the disk at the Seybold Conference in Los Angeles.

Spends two months photographing in the Mixtec region of Oaxaca, Mexico, for *National Geographic*.

1992
I Photograph to Remember is aired as a documentary on KCET, Los Angeles public television.

Directs a postgraduate seminar on image-making in the age of digital technology at the Art Center School of Design in Pasadena, California.

Lectures on ethical issues related to digital image-making at the Seybold Conference in San Francisco.

Begins work on a new CD-ROM disk and its corresponding book and exhibition, *Truths & Fictions*.

1985
Tiempos de América, published by the Comune di Anghiari, in Italy, with an introductory text by Raquel Tibol, as part of the award, "Premio Internazionale di Cultura Città di Anghiari."

"Rio de Luz," a collection of photographic books by Latin American photographers (project organized by Meyer). Mexico City: Fondo de Cultura Económica.

1986
Espejo de Espinas. Introduction by Carlos Monsiváis. Mexico City: Fondo de Cultura Económica.

1988
Los Cohetes Duraron Todo el Dia, commissioned by Petroleos Mexicanos. Received first-place award for personal work at the Maine Photographic Workshop's Book of the Year Awards, Rockport, Maine, 1989.

1991
I Photograph to Remember, CD-ROM, New York, New York: Voyager Company. Presented at the Seybold Conference, Los Angeles, California.

1995
Truths & Fictions, CD-ROM, New York, New York: Voyager Company.

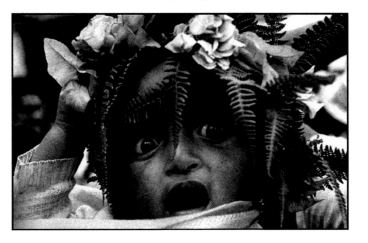

GOOD FRIDAY, 1980

EXHIBITIONS

Selected One-Person Exhibitions:

1978
"Testimonios Sandinistas," Casa de las Américas, Havana, Cuba.

1979
"Testimonios Sandinistas, parte II," Nicaragua-Homenaje Plástico, Salón de la Plástica Mexicana, Mexico City.

1980
"De Minha Terra: Realidades Lendas e Mitos," Museo da Imagem e do Som, São Paolo, Brazil; Centro de Artes, Universidad de Pernambuco, Brazil, and the Museo de Arte Moderno Salvador, Bahia, Brazil.

1981
"Photographs by Pedro Meyer," CityScape Foto Gallery, Pasadena, California.

1982
"Fotografías de Pedro Meyer," Fachhochschule Bielefeld, Germany; Galerie 666, Paris, France; Café los Geranios, Coyoacán, Mexico City.

1983
"Tres Fotógrafos Mexicanos" (with Victor Flores Olea and Graciela Iturbide), Museo Nacional de Bellas Artes de Cuba, Havana, Cuba; Casa de la Cultura "Fernando Gordillo," Managua, Nicaragua.

"Fotografía de Pedro Meyer," Nikon Gallery, Zurich, Switzerland, and Galería Spectrum-Cannon, Zaragoza, Spain.

1985
"Fotografía di Pedro Meyer," Premio Internazionale di Cultura Città di Anghiari, Palazzo Pretorio, Anghiari, Italy; June's Gallery, Yuma, Arizona; Centro Ricerca Aperta, Naples, Italy.

"Juchitán" (with Graciela Iturbide), exhibition at the Casa de la Cultura of Juchitán, Oaxaca, Mexico.

1986
"Los Otros y Nosotros," a comprehensive exhibition at the Museo de Arte Moderno, Bosque de Chapultepec, Mex-ico City. Introduction to the exhibition's catalog by Vicente Leñero.

"Pedro Meyer, Photographe Mexicain," Douchy-les-Mines, Hôtel de Ville, Centre Régional de la Photographie Nord-Pas de Calais, France.

"Tiempos de América," Sasso di Castalda-Edificio Scolastico, Comune di Sasso di Castalda, Potenza, Italy.

1987
"Photographs by Pedro Meyer," San Francisco Museum of Modern Art, California.

1988
"Pedro Meyer: Mexican Photography," Rantagalleria Photo Gallery, Oulo, Finland.

1989
"Pedro Meyer: Contemporary Mexican Photography," Latinoamérica Despierta Festival, Massachusetts College of Art, North Gallery, Boston, Massachusetts.

"Photographs of Pedro Meyer," Vision Gallery, San Francisco, California.

1994
"Truths & Fictions: A Journey from Documentary to Digital Photography," California Museum of Photography, Riverside; Museum of Contemporary Photography, Chicago, Illinois; Museo de Artes Visuales Alejandro Otero, Caracas, Venezuela; Impressions Gallery, York, England; Rencontres Internationales de Photographie, Arles, France; The Mexican Museum, San Francisco, California; Center of the Image, Mexico City; Corcoran Gallery of Art, Washington, D.C.; Museum of South Texas, Corpus Christi; Houston Center for Photography, Texas. Touring through 1997.

Selected Group Exhibitions

1963–1967
Through the Grupo Arte Fotográfico (which Meyer founded), numerous collective exhibitions in galleries throughout Mexico.

1976
Exhibition (with Manuel Alvarez Bravo and Lazaro Blanco) at Il Diaframma Gallery in Milan, Italy. The exhibition later travels to the Centro Ricerche Fotografiche in Salerno.

"The Photographer's Choice," Witkin Gallery, New York City.

1978
"Contemporary Photography in Mexico, Nine Photographers," Northlight Gallery, Arizona State University, Tempe, Arizona.

"Contemporary Mexican Photographers," Center for Creative Photography, Tucson, Arizona.

1979
"Contemporary Mexican Photographers," Bechtel International Center, Stanford University, Stanford, California.

"Soirée Amérique Latine," Festival d'Arles, France (curator of Mexican photographs).

1980
"Siete Portafolios Mexicanos," Centre Culturel de Mexique, Paris, France, and Forum StadtPark, Graz, Austria.

"Photographes Contemporains du Mexique," Musée Picasso, Château d'Antibes, France.

1981
"Ten by Ten from Mexico," Centro Cultural Chicano "La Raza," Austin, Texas.

"Fotografie Lateinamerika 1860–1980," Kunsthaus Zurich, Switzerland; Festival Horizonte 82, Berlin, Germany; Museo de Arte Moderno, Madrid, Spain.

"Diez por Diez," Tonantzin Gallery, Austin, Texas.

1982
"La Photographie Contemporaine en Amérique Latine," Musée National d'Art Moderne, Centre Georges Pompidou, Paris, France.

"Mexikansk Fotografi," Kulturhuset, Stockholm, Sweden.

1983
"Fotografía Mexicana," Galeria Fotografii "Witryna," Plock, Poland.

"Amigos de Benito Messeguer," homage to the artist, in the Salón de la Plástica Mexicana, Mexico City.

1984
"Fotografía Latinoamericana," University of Genoa, Genoa, Italy.

"Ten Contemporary Mexican Photographers," Diverse Works Gallery, Houston, Texas.

"La Fiesta de los Muertos," Musée d'Art Moderne de la Ville de Paris, France.

"Fotógrafos Mexicanos en la Revolución," Asociación Sandinista de Trabajadores de la Cultura, Managua, Nicaragua.

"Hecho en Latinoamérica III," salón de invitados, Casa de las Américas, Havana, Cuba.

1985
"L'Autoportrait, à l'Age de la Photographie," Musée Cantonal des Beaux-Arts de Lausanne, Switzerland.

"Fotógrafos que Visitan Ecuador," Casa de la Cultura, Quito, Ecuador.

1986
"L'Intérieur du Méxique," Centro Cultural Editoriale "Pier Paolo Pasolini," Agrigento, Italy.

"Eight Mexican Photographers," San Francisco Camerawork Gallery, California.

"Reserved for Export," San Jose Museum of Art, California.

"Homenaje a Jorge Luis Borges," Centre Culturel du Mexique, Paris, France.

"50 Years of Modern Color Photography," during Photokina, Cologne, Germany.

"4 Fotografos Mexicanos," New Orleans Museum of Art, Louisiana.

"10 Mexican Photographers," Museum of Modern Art, New Delhi, India.

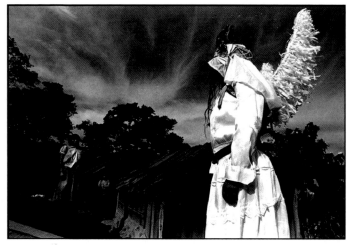

ANNUNCIATION, 1980

"Crosscurrents II: Recent Additions to the Collection," San Francisco Museum of Modern Art, California.

"El Empleo o su Carencia," organized by the Organización Internacional del Trabajo, Santiago de Chile, Chile.

"Primer Salón de la Fotografía," Salón de la Plástica Mexicana, Mexico City.

1987
"Latin American Photography," curated by Fred Ritchin, Burden Gallery, New York City; Society for Photographic Education, San Diego, California; Los Angeles Art Association Gallery, California.

"Imagen de Mexico," Schirn Kunsthalle, Frankfurt am Römerberg, Germany; Art Gallery at the Palace of Exhibitions, Vienna, Austria; Museum of Modern Art, Dallas, Texas.

1988
"Latin American Photography," Photo Days Festival, Buenos Aires, Argentina; Denver Art Museum, Colorado; Santa Barbara Museum of Art, California.

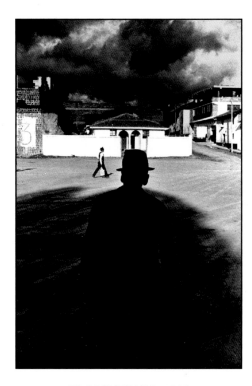

EL ASOMBRADO, 1985

"Contemporary Mexican Photography," The Photography Gallery, Harbour Front, York Quay Centre, Toronto, Canada.

1989
"Museo de Arte Moderno, 25 Años, 1964–1989," Museo de Arte Moderno, Mexico City.

"La Memoria del Tiempo: 150 Years of Mexican Photography," Museo de Arte Moderno, Mexico City; Palace of Exhibitions, Budapest, Hungary; Gallery of the Union of Polish Photographers, Warsaw, Poland; Photo Gallery, International Center of Photography, Berlin, Germany; Museum of Popular Arts and Traditions, Rome, Italy; Sala de Exposiciones del Monumento a los Descubridores Portugueses, Lisbon, Portugal; Association of Art of Alesund & Reykjavik, Iceland; Bienal de Fotografía, Tenerife, Canary Islands, Spain; Musée de l'Elysée, Lausanne, Switzerland; Museum of Anthropology, Amsterdam, Holland; House of Culture, Cankarjev Dom, Llulajava, MP Eslovena, Yugoslavia.

1990
"What's New: Mexico City," The Art Institute of Chicago, Illinois.

"Between Worlds: Contemporary Mexican Photography," Impressions Gallery, York, England; Camden Arts Centre, London, England; University of East Anglia Gallery, England; International Center of Photography, New York City; Santa Monica Museum of Art, California; San Antonio Art Institute, Texas; University of Colorado Art Gallery, Boulder, Colorado; Museum of Photography, Riverside, California; Photographers' Gallery, Dublin, Ireland; Bass Museum, Miami Beach, Florida; Limerick City Gallery, Limerick, Ireland.

1991
"Photo Video—Photography in the Age of the Computer," Photographers' Gallery, London, England; Impressions Gallery, York, England; Ikon Gallery, Birmingham, England.

1992
"Breaking Barriers," Santa Monica Museum of Art, Santa Monica, California.

1994–
"Metamorphoses: Photography in the Electronic Age," organized by Aperture Foundation; Museum at the Fashion Institute of Technology, New York City; Blaffer Gallery, University of Houston, Texas; Philadelphia Museum of Art, Pennsylvania.

ACKNOWLEDGMENTS

Matters of the soul played a significant role during the making of *Truths & Fictions*: the loss of dear ones, and mourning their loss; the loss of a relationship and mourning that as well; new family responsibilities to look after; changing directions in my work; acquiring new skills; retraining and going "back to school," as it were; adjusting to the realities of another country; the body in need of repair: an operation here and there. After all that, however, the light at the end of the tunnel. A new companion came into my life, we married and celebrated over and over again, in various countries and continents, as if on a permanent merry-go-round. Her presence became pivotal in bringing it all together, which is why, when thinking of all those to whom I wish to express my gratitude, the first person who comes to my mind is my beloved wife, Trisha.

A body of work that started out in the world of analogical information would in time become digital, only to end up once again as analogical data in the form of this book, which owes its existence solely to the tenacity and dedication of Michael Sand. It was he who made it possible for this work to migrate to the printed page of a book. The excitement with digital technology that Michael acquired over the recent past was instrumental in bringing this work to the attention of his colleagues at Aperture. Michael Hoffman, a long-standing supporter of photography, had the courage to explore the potential offered by new strategies of image making. Wendy Byrne brought to the pages of this book the harmony and structure that good design delivers; when well done, it becomes transparent. In addition to her excellent design decisions, Wendy adapted marvelously to this new stage in the digital revolution, in which the photographer, armed with new tools for design, makes forays into what used to be the sole domain of the designer. This level of interaction can be a source of immense pleasure, especially when carried out with good spirits such as Wendy's during this entire project.

Since all the technology surrounding pre-press digital-image-making dates back only a few years, to say that you have "experience" may be a questionable claim. That is why it was so important to find someone willing to explore and experiment without hesitation in tackling the challenges that arose. Reggie Greene and Barbara Kimbrough at Icon West made a vital contribution to the final quality of this book. To Richard Benson and Michael Ellis of Willow Six Tech for their generous advice, my appreciation.

I suppose every aspect of one's work has roots in something that happened earlier. This is immediately apparent if one looks at the catalog for "Los Otros y Nosotros," an exhibition of my work that opened in 1986 at the Museum of Modern Art in Mexico City. Oscar Urrutia, the director of the museum at the time, was instrumental in organizing that show.

Felipe Ehrenberg first brought to my attention the very existence of the Guggenheim Fellowship, to which I applied upon his urging and which—to my own surprise—I also later received. James Enyeart, Fred Baldwin, Wendy Wattris, Cornell Capa, Van Deren Coke, Nick Graves, and David Lyman made it possible through their cordial invitations to participate in some of the activities that they organized over the years, which allowed me to "get the ball rolling" on the fascinating subject of the United States of America.

My extended conversations and correspondence with Fred Ritchin on subjects related to new technologies were a source of constant stimulation. One of those letters even found its way into his first book, *In Our Own Image*, which addressed such issues. Those conversations really sparked my imagination; I still keep at home in Mexico City an illustrated article Fred sent me with the first altered images I had ever seen, including one of the Statue of Liberty in the middle of Manhattan. Those pictures had been created on a multimillion-dollar Scitex computer. Little did I know at the time—when Fred and I first sat and conversed about the impact of altered images while sipping *mojitos* at a bar in Havana—how soon all those expensive tools would become available to us ordinary mortals, and therefore end up influencing

all of my future photographic work. I was hooked the moment I saw that picture.

Neither do I forget Fred's hospitality in allowing me to make his apartment a place from which I could go to work while photographing Manhattan. When it wasn't Fred, it was Sandra Levinson, Fran Antmann, or Max and Joyce Kozloff who gave me sanctuary when visiting New York.

Max Kozloff also came to visit me while I was an artist in residence at Arizona Western College in Yuma, Arizona. Nick Graves, Bob and Joanne Davis, Peter Jagoda, and Pat and Marty MacCune became my extended family during those months I spent in Yuma. I had been invited to photograph "whatever I wanted," and for this privilege I was even given a stipend, a car to drive around (we called that 1960 VW with almost no lights and questionable breaks *Rocinante*, meaning "tired old nag," but it got me around), and all the materials I needed. Up to my visit in Yuma, I had never before lived in a small U.S. town. It became a very important experience for me. Years later, after having reviewed tens of thousands of images made over these years, a substantial number of the pictures taken during that time made it to the final edit of my work.

The "no strings attached" grants I received from the Arizona Commission on the Arts and the Guggenheim Foundation were extraordinary in that they just assumed that I would make the best use of such support. I tried to the best of my ability to be worthy of their trust.

James Enyeart, former director at the Center for Creative Photography in Tucson, Arizona, and now director of the George Eastman House, in Rochester, New York, was the very first person I ever saw using a personal computer—he used it for word processing. My jaw dropped when I grasped what he was able to accomplish right there at his desk.

Before I began using work prints generated from the computer it was Leor Levine in Los Angeles who consistently and patiently printed those for me, since I had no darkroom of my own while working in California. Jonathan Reff, when not busy with his 8-by-10 view camera, also assisted me in making a great number of contact sheets. Out of this collaboration with Jonathan grew a friendship that extended into the "digital domain."

Pilar Perez, who has been instrumental in organizing the traveling exhibition of this work, first introduced me to Graham Nash, whose initial explorations with the Iris ink-jet printer would later on become an essential link with my digital work. This was possible in great part due to his willingness to share those explorations with others such as myself. Mac Holbert and Jack Duganne were my companions in the arduous process of discovering how things actually worked when trying to accommodate the number of pixels to the best Iris print possible, something they now have come to master so proficiently at Nash Editions.

At a Memorial Day picnic organized by Kira and Bill Viola at their home in Long Beach, California, a couple sitting opposite me listened with patience and courtesy while I rambled on enthusiastically trying to introduce them to the virtues of Beethoven's Ninth Symphony on an interactive CD-ROM. Little did I know that my audience consisted of the publishers of the disk I was talking about, the masterful work done by Robert Winter at the Voyager Company. This was a providential encounter with Aleen and Bob Stein, which in time would lead to the production of two disks under the Voyager label.

When acknowledging those whose presence was important to the outcome of this project, in all fairness, my colleague and one-time companion Graciela Iturbide needs to be highlighted. She contributed to the process by exercising her considerable talent; her images, like good old friends, accompanied me in the back of my mind during this long journey. Patricia Mendoza, Yolanda Andrade, Mariana Yampolsky, Rubén Ortiz, Eniac Martinez, Saul

Serrano, Mauricio y Manuel Rocha, Pablo Cabado, Pablo Ortiz Monasterio, Francisco Mata Rosas, Raquel Tibol, Adrian Bodek, Carlos Jurado, Rowena Morales, Carlos Somonte, Vida Yovanovich, Felipe Ehrenberg, Víctor Flores Olea, Leonardo Sak, Marco Antonio Cruz, Pedro Valtierra, Emma Cecilia Garcia, Alejandro Springall, José Hernández-Claire, Fabrizio Leon, Andrea Di Castro, Carmen Lira, Bertha Navarro, and Rogelio Villareal are some of the colleagues and friends from Mexico who, through their letters, visits, phone calls, newspapers, and messages sent through others, kept me up-to-date and thus allowed me to feel engaged with the cultural life I left behind.

And what to say to all those friends who so generously responded to my correspondence from different parts of the world, putting aside some time in order to make a meaningful contribution to this project? They are already mentioned in relation to their respective contributions in the correspondence section of the CD-ROM. This project would certainly be poorer without their thoughts and ideas.

Kerry Tremain and Steve Dietz made the valiant effort of publishing excerpts from this project as it was in the process of maturing. With the best of intentions, Tom Kennedy invited me to participate in an editorial project for *National Geographic* magazine, which brought me to photograph in the southern part of Mexico for several months. The project turned out to be an unmitigated disaster—I guess it just wasn't meant to be. However, it delivered to my archive a wealth of material which otherwise I might not have sought, at least not at that time. Those pictures became the invaluable source from which I was able to create my digital images of the Mixtec people from Oaxaca. By contributing, although indirectly, in such a meaningful way to *Truths & Fictions*, Tom Kennedy's original, well-intentioned attitude eventually found its way into this project, and for that I am most grateful.

The California Museum of Photography at Riverside first exhibited and presented the printed exhibition of "Truths & Fictions," and organized the world tour of this work. For this, I want to thank Jonathan Green, director of the museum, and all of his splendid staff. Jonathan's support and nurturing patience made the three years we worked together on the exhibition a particularly pleasant experience. It takes a unique type of person in the capacity of museum director to stick with a project that by necessity was constantly being altered. New technologies opened new opportunities and in turn these altered the schedule. Not once did I hear a censoring remark, or one which would put a damper on creative thoughts. The form and content of the entire exhibition were subject to constant re-evaluation, nothing was left unchanged. The turmoil that such a chaotic approach generates could only be sustained by a director with a quixotic temperament and a clear commitment to expanding the horizon, and Jonathan Green had both.

Finally, I would like to express my utmost appreciation to the Guggenheim Foundation, the Arizona Commission of the Arts, the National Endowment for the Arts, and the U.S.-Mexico Fund for Culture; their generous support helped to make "Truths & Fictions" become a reality.

Pedro Meyer, Los Angeles, California, 1995

Library of Congress Catalog Card Number: 94-79645
Hardcover ISBN: 0-89381-608-6

Pre-press work by Icon West, Los Angeles, California
Color separations by Pedro Meyer
Printed and bound by Artegrafica S.p.A., Verona, Italy

The Staff at Aperture for *Truths & Fictions* is:
Michael E. Hoffman, Executive Director
Michael Sand, Editor
Stevan Baron, Production Director
Sandra Greve, Production Manager
Wendy Byrne, Designer
Diana C. Stoll, Copy Editor
Nicole Ray, Editorial Work-Scholar

Aperture Foundation publishes a periodical, books, and portfolios of
fine photography to communicate with serious photographers and
creative people everywhere. A complete catalog is available upon request.
Address: 20 East 23rd Street, New York, New York 10010.
Phone: (212) 598-4205. Fax: (212) 598-4015.

First edition
10 9 8 7 6 5 4 3 2 1

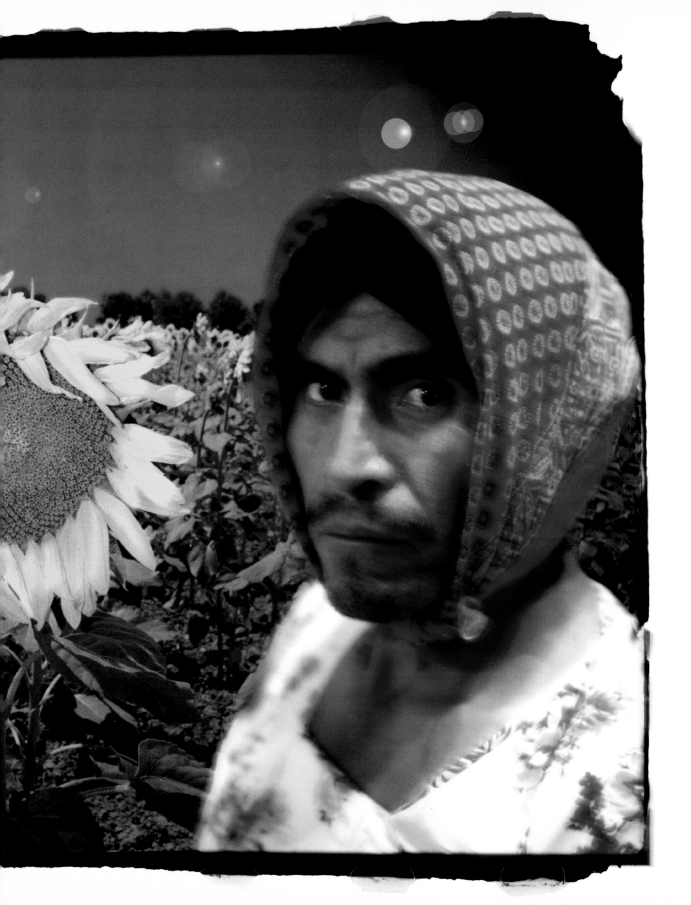

SUNFLOWERS, 1981/94